AN ERA WITHOUT MEMORIES

JIANG JIEHONG

AN ERA WITHOUT MEMORIES

CHINESE CONTEMPORARY PHOTOGRAPHY
ON URBAN TRANSFORMATION

132 ILLUSTRATIONS, 115 IN COLOR

Thames & Hudson

ON THE COVER
Front: Chen Qiulin, *The Garden, No. 4*, 2007. Courtesy Chen Qiulin, Thousand Plateaus.
Back: Zhuang Hui, *Longitude 109.88° Latitude 31.09°*, 1995–2008. Courtesy Zhuang Hui.

ABOUT THE AUTHORS

Jiang Jiehong is Professor of Chinese Art and Director of the Centre for Chinese Visual Arts at Birmingham City University. He has published extensively on contemporary Chinese art and curated many international projects, including most recently the Guangzhou Triennial (2012) and the 'Harmonious Society' exhibition at the Asia Triennial Manchester (2014).

Stephan Feuchtwang is Emeritus Professor of Anthropology at the London School of Economics. A renowned expert on China, he has published widely on the subject, particularly in the fields of popular religion and politics, with recent research on grassroots urban life and government in China.

An Era Without Memories © 2015 Jiang Jiehong

Art direction and design by Martin Andersen / Andersen M Studio
www.andersenm.com

First published in 2015 in hardcover in the United States of America by Thames & Hudson Inc., 500 Fifth Avenue, New York, New York 10110

thamesandhudsonusa.com

Library of Congress Catalog Card Number 2014944639

ISBN 978-0-500-54443-3

Printed and bound in China by C&C Offset Printing Co. Ltd.

Contents

Preface

The year 1979 appears to have been a turning point in Chinese art history. In September, the Star group held their first unofficial exhibition, marking the beginning of contemporary art in China. 1979 was also a watershed year for the development of contemporary photography, which, as part of the increasing visibility of Chinese art in the international arena, proved to be one of the most popular media. Previously – during the Cultural Revolution (1966–1976), in particular – the publication and exhibition of photographs had served strictly propagandist purposes. When Western photography was introduced through a host of photographic journals and magazines published after 1979, many new photo clubs emerged and numerous exhibitions were staged across the country. The April Photography Society's first exhibition, 'Nature, Society and Man', opened in Beijing's Sun Yat-Sen Park on 1 April 1979. Unlike the 'Stars Art Exhibition' (*Xingxing meizhan*), presented by the Star group of avant-garde painters and sculptors, and openly challenging Mao Zedong's dictatorship, this show featured photographs that were seen to be apolitical and formalist, promoting a new understanding in the domain of visual aesthetics beyond the party's control. The photographic representation of private love, abstract beauty and social satire was considered revolutionary in a quite different way.[1]

Through the New Wave movement in the 1980s, documentary photography became central to the development of Chinese photography in revealing the 'truth' in the social and political situation of the time. But for a new generation of artists, who were originally trained as painters or sculptors, it has not been enough merely to experiment with photographic technologies or to break away from conventional political vocabularies for capturing 'real' moments in life with alternative aesthetic precepts. These artists initially found inspiration in performance and installation, in which photographic elements were employed. Since many of the performances were executed in private, without a public audience other than friends, the photographs that documented the events became the 'original'.[2] At the core of these photographic representations is not their documentary function but rather the revelation of the individuality and identity of the artists. *New Photo* (*Xin sheying*), a handmade underground periodical edited by Rong Rong and Liu Zheng, and consisting of only twenty to thirty copies of each issue, became one of the few platforms for artists to publish their work. During the 1990s, these works – often termed 'conceptual' (*guannian*) or 'experimental' (*shiyan*) – aimed to drive substantial change in Chinese photography, within its own cultural context. Contemporary photography began to establish its independence as an art form in China.

If, in the 1990s, Chinese photography developed its critical proposition against political agendas and gained an alternative position by divorcing itself from the mainstream, then today it faces a different but possibly even more powerful challenge: dealing with the

extraordinary changes caused by China's urbanization. Within the past two decades, the ever-growing population has seen the most astonishing development in both scale and depth. If the mission of an artist is to think, imagine and critique, how is it possible to keep up with such a society in flux? If photography has always been a means of holding onto the present at the moment of its demise, what photographic strategies are appropriate for the overwhelming pace and extent of transformation in contemporary China? As daily changes are experienced as part of urban existence, what does China really look like, and what are the relationships between photographically recorded 'facts' and the instability of what has been seen; between artistic response, imagination and memory?

One of the earliest Western visions of China, during its imperial times, was shaped by the late 13th-century travelogue commonly known as *The Travels of Marco Polo*, nicknamed *Il Milione* (The Million). The Venetian merchant Marco Polo dictated the book in 1298, and it describes his travels to China between 1271 and 1291. But China would only become more directly visible to most in the West after the invention of photography in 1839. As the semi-official photographer of the Anglo-French North China Expeditionary Force, Felice Beato (1832–1909) took the first set of images of the country. During the several months of his trip, in 1860, he made approximately one hundred large plate photographs (10 × 12 in.) around the city of Guangzhou. These documentary photographs offer intriguing images of Qing dynasty streets, houses, arches and temples: ordinary places in everyday life [1, 2]. Only 150 years later, none has survived. This kind of loss applies to almost all the major Chinese cities, sustained by wars and revolutions, including the most recent: the revolution of urbanization. Just a few historical sites have been preserved and set aside as tourist attractions. The photographic images of 1860 have been 'untrue' for many decades, their original subjects no longer extant to act as proof of their reality. But to some extent, within the context of China, these photographs do not necessarily function to manifest what was and has been lost. They are somehow transformed from the recorded to the imagined, from the documentary to the artistic, extending the visual mystery of the Middle Kingdom (*Zhongguo*, the literal Chinese name for China).

With the rapidity of today's urban changes, the visual experience of contemporary China is singular, filled with excitement and anxiety [3]. Histories have been destroyed, and heritage, memories and futures are being reinvented. For insiders – those artists who are living through the accelerated urban development and its disturbance – the camera has naturally become a convenient instrument. These artists have responded to what is already a surreal experience, sometimes nostalgically, sometimes critically and sometimes poetically. Above all, the role of photography in this unprecedented era of social, ideological and cultural transformation is now being re-examined.

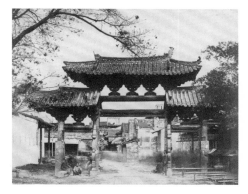

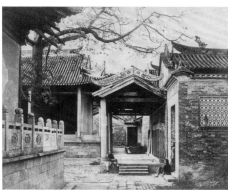

1. Felice Beato, *Arch near Yamun, Canton*, 1860
2. Felice Beato, *Gallery in Confucius Temple, Canton*, 1860

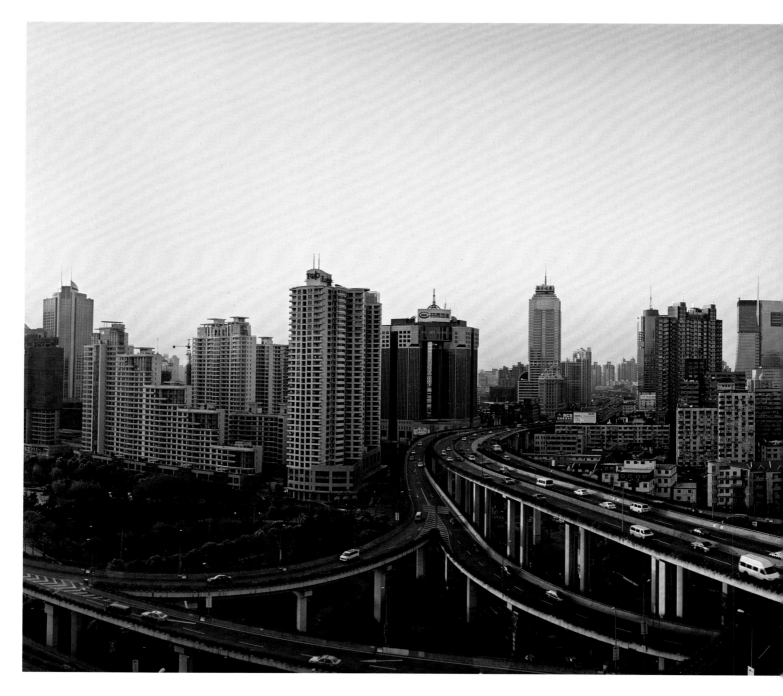

3. Edward Burtynsky, *Urban Renewal No. 1*, 2004

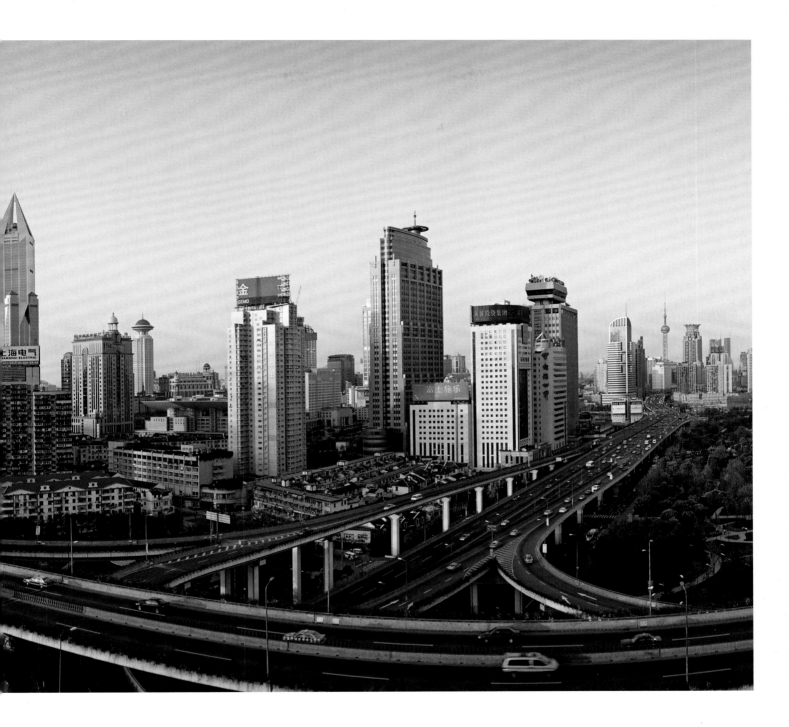

Introduction. 'Urban Appearances'
by Stephan Feuchtwang

'[W]e've damaged and become disconnected from our history and culture. We knock things down on a whim and relocate everyone – all our cities look the same, there's nothing unique about them.' Pan Jiahua, director of the Chinese Academy of Social Sciences' Institute for Urban and Environmental Studies[1]

The images in this collection are creative responses by artistic residents to the destruction and rebuilding of their cities. In the space of just thirty years – between 1980 and 2010 – the urban population of China grew from under 20% to over 50% of the total of over 1.3 billion. The number is even higher if you also count, as official statistics do not, the number of rural districts and villages with urban population densities and non-agricultural employment. In that time, towns grew into cities and cities expanded. They grew at such a pace that nearly all of urban China has been built since 1980.

Most of the old parts of the expanding cities have been destroyed. The Maoist regime was ideologically against 'old things' and had already destroyed much, but the post-Mao craze for modernization has destroyed much more. It has replaced the old with pastiches of the centres and suburbs, skyscrapers and villas of the most powerful and wealthy imagined 'West'. But since 1990 laws have been passed and plans issued to conserve monuments of the history of civilization in China. So there is not just destruction of memories; there is also a construction of reminders and reinventions of pasts. These, too, dislocate residents, who have to move into new apartments in the suburbs.

Most urban residents have moved at least once, and often two or three times, in their lives. While relocations generally mean an improvement in comfort, space, services and utilities, residents have had to be resourceful – usually despite, rather than with the help of, urban authorities – in finding or sustaining a livelihood and in maintaining contact with one another.

Many streets and alleys that were home, many buildings that were the familiar landmarks in mental maps, many street markets that were meeting places – so many triggers to memories – have been bulldozed and replaced with boulevards, covered markets and plazas. Cities have been built in and out of the rubble of buildings. Villages and towns absorbed by cities have been destroyed or changed beyond recognition. Their temples and halls, which registered their own histories and the local sense of being part of a larger history, have been demolished or decommissioned, even while the same institutions and their buildings have been renewed in the countryside not yet urbanized. This is an era of destroyed memories in urban, but not in rural, China.

For years, beside the tallest towers, the icons of Chinese cities have been the earthmover, the crane, and the 'nail household' refusing to move until adequately compensated and re-housed. For a time there was even on international web sale a game of strategy called 'Nails', in honour of the famous householder who stood out, winning increased compensation from a developer acting for the city of Chongqing. The homeowner's stand was a guerrilla action, using the web and journalists' investigative support, that lasted two years until a settlement was reached in 2007.

Internationally – not just in China, the issue is so widespread – new words have been coined to describe the wanton destruction of homes and of memories by developers, planners and governments of growth. 'Domicide' describes the destruction of homes and enforced relocation. 'Memoricide' describes the destruction of the past through the eradication of neighbourhoods as well as residences. As Qin Shao in her book *Shanghai Gone: Domicide and Defiance in a Chinese Megacity* shows,[2] such loss engenders an intensity of response and persistence in seeking redress that has every year resulted in tens of thousands of 'incidents' across China, creating a quickened political pulse of small events fibrillating the harmony and order that government defibrillators seek in promoting their definition of 'civilization'.

The Chinese word for civilization (*wenming*) combines pride in the past and aspiration for a future that is every day being realized by some, but not yet most, of the population – a future of good health, hygienic habits, educational qualifications, skills in the most advanced sciences, harmonious social relations and a lifestyle that includes all the best that can be imagined in the most advanced economies in the world. To promote the civilization of a confident people and its government, cities have been scenes of the construction of memories through a regime of visibility in which, among other features of display and spectacle (the other side of which is the semi-visibility of walled estates and their equally semi-visible opposites, which are the urban villages of migrant workers), cities brand themselves using selections of their long histories and new landmark buildings – icons of their past and their future.

What follows is an elaboration of this regime of visibility to provide a context for the memorable and often disturbing images – responses to the urban environment – that Jiang Jiehong has gathered.

Destruction and development

Urban construction is everywhere destructive. Developers and their patrons have summarily wiped out the memories and places on which they make their plans, as if nothing was there to begin with. As if to make up for this, urban planning now makes 'place' and 'sense of place' into a fetish, as though the planner could create places in one go where there had been places that were gradually made by residents over a number of generations. Architects' and planners' apparent sensitivity to place-making is either utopian or cynically commercial: place as a democratic public space, place as plaza and mall. It has been so from the origins of modern town planning. In the UK, this began in the mid-nineteenth century with alarm about the conditions of rural migrants in the new industrial cities of England and Scotland. In Chinese cities, the cheap labour that builds urban developments and infrastructure is supplied by rural migrants who number at any one time more than 200 million, approximately a third of the urban population [4]. They are feared and despised by registered residents as less civilized. Similarly, 160 years earlier in England, the worst-off, most degraded and most alarming were Irish farmers escaping from the potato famine, created by landowners' commercial interests which also dominated the new cities to which the farmers fled. These migrants were described by landowners and the reformers they supported as savages, or as inhabiting the lowest level of civilization and dragging the more civilized down.

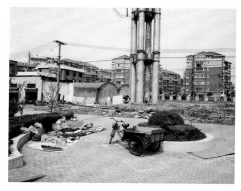

4. Edward Burtynsky, *Urban Renewal No. 9*, 2004. Looking into this strange building site from what must be a street with passing pedestrians, one sees an illegal street seller, probably a rural migrant, creating the mess that every planner tries unsuccessfully to clear away.

The 1851 census of the UK was the first to record that over 50% of the population lived in towns and cities. The largest populace was London's, but much faster growing were the manufacturing cities of northern England, and Glasgow in Scotland, at least 40% of whose population growth was attributed to rural migrants. In Bradford and Glasgow, 70% of the population over twenty years of age were born elsewhere, including young women employed as domestics in the houses of the newly rich. All of this has been repeated in China, 160 years later, where, despite the lively street life created, the new urbanized villages house the overcrowded, insanitary, rented accommodation of migrants. But while they may be wretched in their cramped accommodation, they are nowhere near as wretched as the Manchester residents exposed in 1832 by James Philip Kay, a doctor and devout Christian, in his book *The Moral and Physical Condition of the Working Classes Employed in the Cotton Manufacture in Manchester*. Preventive medicine and literacy are extended in China even among rural migrants, whereas there was no such extension in England and Scotland. The worst public housing in Chinese cities has a public lavatory as one of its minor social hubs and source of social tensions, and public baths as a major meeting place, whereas in what is now gentrified Bloomsbury in London human excrement ran in the public ways when it was first settled.

Tristram Hunt's *Building Jerusalem: The Rise and Fall of the Victorian City*,[3] from which I take these British facts, depicts the two sides of the first industrial urbanization as a contrast of terribly contaminated, stinking and noisy alleys with fine neoclassical buildings of civic pride. The former were the subject for scientific and Christian reform, schemes for the building of infrastructure, such as sewage systems and fresh-water pipes, and slum clearances to prevent disorder, crime and disease – a salutary but nevertheless devastating destruction of the places that residents had succeeded in making for themselves, and a destruction that continued into the 1960s. Victorian and twentieth-century city leaders, in both private and public spheres, fostered new institutions of local states: public health boards, work houses, the modern conception of town planning and the encouragement of literacy. In China, all this comes under the concept of 'civilization', just as it did in England and Scotland. And, in both, 'civilization' establishes a hierarchy of quality and a segregation of housing and lifestyles.

China's current fastest and most extensive urbanization occurred after a long period of republican revolution, including the thirty years of Maoist top-down industrial urbanization and its destruction of what was considered old and backward. Similarly in Europe, after 1848, known as the 'Spring Time of the Peoples' in acknowledgment of an awakening of urban dwellers in the industrializing countries, the idea of proper housing was established along with its corollaries of acceptable standards of living space, light, ventilation, piped water, sanitation and services, and a minimum threshold for survival that is now commonplace throughout the world, even where it is infrequently implemented. Affordable housing for those living on low incomes is still inadequate to measured need in China, as it is in the UK and elsewhere.

Beside and beyond housing for the European poor were residential areas for middle-class families, clearly segregated from the working classes. Exactly the same segregation has occurred in Chinese cities, but it is not the result of an aristocratic, professional, industrialist and Christian realization that privileges depend on the building of a local state and private civic philanthropy. Missions to the poor are not a religious civilizing vocation in China, but the pursuit of a strong and atheist state working for its legitimacy through its local governments and the private developers upon whose profits and fees these local states depend.

The aristocratic developers of London, and what they destroyed, are traceable in the names of streets and parks, just as the existence of now-destroyed temples is traceable in names of Beijing streets and underground stations. Chinese equivalents of the public square – which is one of the characteristics of the patrician landowners' development

of London through their master builders and financiers – are now landscaped spaces in housing estates large enough for children to play and older people to do their exercises in. They always include round, open but roofed pavilions, like British park bandstands, but featured along with mounds and ponds as characteristic of Chinese gardens. What they have destroyed returns, like the return of their ghosts, in the designation of parts of cities as 'villages' or 'gardens', *cun* and *yuan*.

The ubiquitous proclamation of civilization

China's urban present is an overcoming of its past. The humiliation of being known in the nineteenth century as 'the sick man of Asia', a locus of famines for the rescue operations of European and North American charities; the demeaning consequence of having foreign trade and investment forced upon it by gunboat diplomacy and of not having been able, as the Japanese imperial nation was, to defend its domestic economy in order to encourage its own industrialization. The history of being invaded and occupied by a resurgent Japanese empire and all the other degradations were eventually overcome by the expropriation of foreign-owned industry and (with Soviet help) the undertaking of endogenous industrialization. But the greatest overcoming of the past started with the dismantling of the command economy and the onset of the extraordinary manufacturing boom that turned China into the factory of the world and led to the indebtedness of the globe's greatest economic powers, the USA and the EU, to Chinese sovereign funds and investments. The Communist Party regime is now proudly declaring its own material and spiritual civilization to its citizens and to the world.

Wenming is a new term and aim, defined by Chinese governmental ideas of modernity and global standards. It sets up a hierarchy of urban living environments, from villas in walled estates to the cramped quarters of the migrant workers who service these estates. It is the celebration of a glorious and greater (longer) heritage than that of any other nation, and an individual aspiration to possessing the signs and manners of civilization, including educational qualifications, travel abroad, and a lifestyle that demonstrates both wealth and breeding, sealed off as far as possible from those of lesser wealth and breeding. It is the Chinese version of meritocracy, which assumes opportunities for upward social mobility in an increasing polarity of wealth and income, so that those who achieve can presume (usually falsely) to be in the higher statuses by their own merits and the market.

On Line 13 in the Beijing underground system – through gaps between the heads and shoulders of standing passengers coming in from the outer suburbs, some of their faces

slightly lit by their phones – you can see a pixellated running band of information and exhortation in red on black in the space above the windows. It is there not only to inform observers of the name of the next station (they can also hear this announced), but also to proclaim 'the traditional moral excellence of the Chinese people' (*zhonghua minzu chuantong meide*).

Street furniture is plastered with reminders to be civilized and awards for being civilized. Inured to them, most people pass by unseeing. But the idea of a ranking of what the government calls 'quality' has entered the vocabulary of ordinary speech. In upmarket housing estates, the newly rich inhabitants who bring their rural parents to live with them and to look after their children are decried by other residents for being of lesser quality. We can see this aspiration for civilization in the styles of housing being built. They are the demonstrative shells of ways of living that aspire to the civilization not just of China but of the world.

Chinese pastiche: possessing civilization

Chinese cities are a sometimes depressing, sometimes exhilarating and often amazing series of pastiches, including individual buildings that echo the modernity of the steel, concrete and glass pile with prefabricated panels, topped by a foreshortened Chinese-style curved roof, or else featuring a trope of modernism such as an empty square or a tapered curve. On the other hand, a city or even a village can build its own version of Beijing's imperial city and the huge square in front of its Gate of Heavenly Peace, itself the result of a great destruction of old Beijing. International architects have also been invited by Chinese cities to build truly fantastic forms, which, as everywhere in the world, stand as new iconic brand-marks of the city.

A concrete and steel frame may bear an entire surface of pastiche. I remember seeing in the countryside of southern Fujian in southeastern coastal China in the 1980s a new factory building fronted by a long Grecian colonnade, in the centre of which was a large pediment, on top of which pranced a fan of huge green horses. While admiring this extravagance, with a hint of European condescension, I should have reminded myself that neoclassical architecture is also inventive pastiche, and that fabricated and glorified Chinese pasts have Western equivalents, such as the neo-Gothic architecture of the Houses of Parliament in London. Technological advances in engineering and the production of units for the assembly of buildings have made possible the mass-replication of the elements of Beaux Arts architecture, the Greek orders, the Palladian façades, the

Roman domes and arches, the whole neoclassical architectural rhetoric that was more painstakingly replicated in the construction of Victorian civic pride and the US state capitols to such great effect.

We should also recall that the construction of suburbia is, in the UK and USA, a developer-produced mass invention and replication in miniature of stately gardens and pastiches of the past, from false timbering and imitation statuary to mini Palladian porticos and Spanish hacienda houses. What seems to characterize Chinese pastiche is its sheer scale, as in everything Chinese, but more importantly the scope of the references for replication – even greater than those for which the USA is famous. Whereas in the USA the chief references are to all the old countries of its colonists, in China it is not just Europe but also the Americas and Japan and China itself that are replicated. In China, the technology of construction as well as all other manufacturing processes have been mastered and deployed, with some innovations, increasing the speed and possibility of replication.

Another difference has to do with memory. In the USA, the colonists built their future out of memories of where they or their parents had been, as if in a blank space won from the native populations. A similar story can be told of South Africa and any other settler colony. The great houses at the centres of plantations were new, rich versions of Palladian country houses in an entirely new institution of mass agricultural (slave) production and processing for factories. In China, at this end of the history of capitalist industry, the policy makers, planners and developers requisition land on a huge scale, creating equivalent blank spaces out of villages, many of which were already urbanizing themselves. The houses in such villages, as I saw in the early 1990s, were being rebuilt by owners in the styles that they imagined or found, in magazines or from visits to already rebuilt villages, to be modern: two or three storeys, with balconies, in a 'Spanish' style, walls clad with tiles, and a Chinese roof. Later, in 2012 and 2013, I saw how entirely urban villages with six-storey blocks but still maintaining ground-floor storage and grain-drying areas nevertheless retained their neighbourhoods, their ancestral homes or halls, sometimes their temples. Near cities, even such urbanized villages have been demolished to make way for burgeoning city developments. This is the Chinese version of *terra nullius*, or *terre blanche*, destroying the places made with a sense of their own histories, to construct upon them what we should call dreams or memories of the future, pre-manufactured by property developers [5, 6].

Li Zhang, an anthropologist from the southwestern city of Kunming, has written a fascinating book about property developments for the newly rich in her hometown.[4]

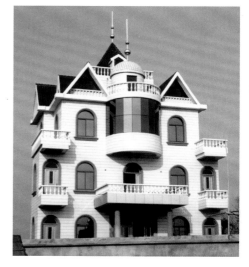

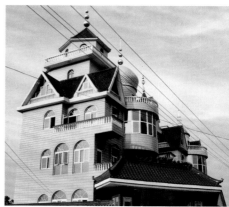

5. Zhang Peili, *Farmhouse No. 3*, 2007.
6. Zhang Peili, *Farmhouse No. 5*, 2007.
These strange amalgams of features are 'Chinese' in the sheer exuberance of their copying.

She called the book *In Search of Paradise* after the developers' schemes and the ways in which they are advertised to spur on and cater to the aspirations of the middle- and higher-income earners, who, with like-minded residents, want to set themselves apart in landscaped estates. One such is 'Think UK – a fashionable living community, a globalized dwelling place', as the developer advertised it. Its architecture is not particularly British, but its street names include 'Windsor Rose Garden' and 'England Apple Park'. The point is to have possession of something that is as good as what is available in the most advanced economies and what is imagined as high-class civilized life. It is to capture an image of a place you could also travel to as a tourist: a nostalgia in advance.

During the Ming dynasty, the gentry elite captured in paintings and gardens souvenirs of places of renown that they had visited or could have visited in China. Now, the better-off aspire to worldwide destinations where they could live, but instead they desire to possess them – in China – in the form of what amount to residential theme parks. These are lived-in souvenirs kept by people who can also afford to travel to the places replicated. Their children will have the names of their home addresses, and other exotic features, as part of their own childhood memories, as well as quite possibly memories of actual visits to these and other foreign destinations.

At the top end, in the richer and bigger cities, the faithfulness of replication is stupendous and much more immediate than the replication that occurred in the USA or South Africa. The same architect who designed Kattenbroek, a section of the city of Amersfoort in the Dutch province of Utrecht, repeated it soon after in Shanghai's Holland Village, where it was in addition dotted with plastic tulips, windmills and oversized clogs. At the very top are such extravagant reproductions as that of the Château Maisons-Laffitte in the Château Zhang Laffitte, a replica made using thousands of photographs of the seventeenth-century original and with the same stone imported to rebuild it in Beijing.

Bianca Bosker, from whose book *Original Copies: Architectural Mimicry in Contemporary China* I take these examples,[5] traces such facsimile reproduction to the imperial Chinese tradition of reproducing in the centre the far reaches of the tributary kingdoms of the empire. The city of Chengde in eastern China contains copies of the palaces and lamaseries of far western Tibet for guests from the region. The eighteenth-century Qing dynasty emperors who built Chengde also had a Garden of Perfection and Light (*Yuanmingyuan*) constructed, in which some of the buildings replicated the style of the palace of Versailles, helped by advice from two European Jesuits. In another of its spaces was a replica pertaining to the Indian city of Sravasti. Elsewhere, near their capital, the emperors had another grand garden estate built – the Yiheyuan – which also included

buildings replicating the far reaches of the empire. Both locations were sacked by the European imperial powers.

Now possession of the world replicated in China is the passion of the rich and the aspiration of the less rich who can only afford the names and some other tokens of modern civilization in the outside world. By possession I mean not just the ownership of replicas, but also the effect on these replicas of their contexts. In the city of Hangzhou is a 105-metre-high (345 ft) replica of the Eiffel Tower, built as the central feature of Oriental Paris. In the vicinity can be seen a broad, landscaped highway flanked by plain high-rise blocks and lamp-posts hung with Chinese advertising banners. Thus, placing Paris in Hangzhou is an effectual and surreal act of possession.

Urban planning and architecture as exhibition

Every city's planning department exhibits a model of the city, showing what will be preserved and what will be built. This is nominally for availability to statutory consultation with the affected residents, but it is also a spectacle in itself, a counterpart to heritage memory projects. Some exhibits are very large and under glass at floor level so that you can walk over the present-and-future city, with its old centres and its new business districts, its old university campuses and the new campuses to which most faculties will move, in satellite cities linked by new broad ribbons of multi-lane motor transport and over- and under-ground railways. In Chinese cities, new university campuses are convenient public-sector heralds for what are hoped and intended to be new centres of private-sector employment (in the old cities of Europe, such projects tend to herald the regeneration of docklands and defunct manufacturing zones).

The often impressive and pleasing model visions of the city – of redevelopments of the older parts and the new satellites in its rural hinterland – are the product of a number of different impulses. In their realization they are, as are all plans in all parts of the world, compromises between even more powerful agencies, public and corporate. One pressure comes from ambitious political leaders who want in the time of their appointment, for instance as the Party Secretary of the municipal government, to make a mark that is also a bid for promotion within a tenure of five years. Overarching this are larger-scale and higher government plans for twenty-year spans.

The design of the different parts of the master plan is itself under different conflicting pressures. One relates to the client, such as a university or a municipal government and,

say, the public square in front of its new building aimed to impress with size – the opposite of design for human-scale interaction – while, on the other hand, planners know that they should be building on a more human-friendly scale. Every Chinese planner with a university qualification knows the design principles of integrated residence and work in garden cities, and of building to a human scale from Ebenezer Howard onward, and of grass-roots-upward principles of planning from Walt Disney to Jane Jacobs. They know about creating spaces with walkways, not obstructed by great gashes of boulevard, and about the importance of local workplaces, which is to say attracting private investment, small and large, to create jobs within short travelling distances. The problem the satellite cities face is the problem of the failure of the garden cities in the UK, where their industrial sponsors could not maintain a presence and the cities just became suburbs of the central conurbation. In the USA, the problem of sprawl and most recently the suburbanization of the poor – moved out of disastrously violent and ghettoized projects in city centres since the 1970s into more mixed but equally isolated and now suburban ghettoes of poverty – has led to attempts in dozens of its cities to reverse this trend and change the economy through networks of businesses, universities and municipal governments to create new high-technology and innovative manufacturing enterprises in city centres.[6]

Chinese cities have become amalgams of the beltway and huge ribbon highway, demanded by the domestic motor car industry, with suburban or satellite cities of pleasant high-tech industrial parks or new city administration and business districts alongside relocated low-income commuters in social housing projects, surrounding central city redevelopment for tourism and business headquarters. All of this is run through with developer/consumer-led estates of commercial housing. The juxtaposition but sealing off of different types of housing and functions in newly zoned satellite as well as central city developments is the result of a seeking for social integration on the part of planners and their frustration by the grandiose projects of city politicians and the aspirations for civilization by commercial buyers of residential 'paradises'.

Images of the desired: rendering and building

The image a city presents is both virtual and real. From whatever angle of view and on whatever scale, it is a mixture of a general impression and many factual details that are so numerous they cannot be taken in. The urban landscape, like any individual building complex within it, has been pictured virtually and then become the basis for the next picture to be added to it. Three-dimensional virtual imaging of a building or a

building complex is called 'rendering', and it provides realistic images of the outcomes. Doreen Bernath, teacher of architecture and expert on Chinese rendering, notes that an architectural design in contemporary Chinese practice typically unfolds from pictorial renderings right from the start.[7] This is, as she points out, an inversion of the logic in Western architectural discipline, where pictorial rendering comes last, after the various stages of a plan. In Chinese practices, therefore, 'a non-architectural category disrupts the order and becomes the driver of an architecture-making process'. This puts the client and developer in the same place as the architect and builder, instead of in a sequence of client, developer, architect, then builder, since, with the design software developed for China and elsewhere, the rendering can be used in several different ways. It can be translated into a plan for both architect and builder; it can be transmitted as imagery for the client to check the building as it is constructed; and, on the site itself, it becomes the property developer's hoarding, advertising what will be built and hiding what has been destroyed [7].

7. Xu Zhengqin, *The Second City, No. 1*, 2007. Through the tear in this vision of conventional modernity is a glimpse of the rubble of destroyed homes and removed residents.

Rendering does two things. It persuades through details, which Bernath calls 'reality-effects'; and it succeeds to a tradition in China of producing effects from a relational, configurative way of disposing the elements of a 'plan'. The end result is 'a rhetoric of details that liberates the iconic, the primary image or message so to speak, to vary, to dramatize, while the effectiveness of the overall picture is kept by embedding it in a familiar background'. The imagery then repeats itself in a recursive fashion, from rendering to building and to rendering again. 'By subjecting the iconic to repetition, its identity is restructured, disposed in accordance to increasingly familiar situations, which enables it to supply the next set of persuasive idioms.' The very multiplication of the new makes it both familiar and strange, by increasing its aggregate and therefore its scale of effects: the uncanniness of all cities looking the same because they have all been built or rebuilt in the same period. Earlier in this introduction (p. 18), I referred to Bernath's 'reality-effect' as an act of possession by the unremarkably familiar, such as the lamp-post and other street furniture including advertising or propaganda slogans. It is also the mundane attached to the desired image of the high-rise of modernity, such as a window and its lock, security bars, and an internal staircase in a tower block.

Rendering treats both the virtual and the real as a configuration, in the long tradition of manuals, such as the twelfth-century architectural manual, the *Principles of Building* (*Yingzao Fashi*), but also musical, sexual, calligraphic and other manuals, which are guides to efficacious dispositions, in which each element is a creative or destructive response to the others. The *Principles* contains a mix of detailed drawings of timber beams – just as manuals for painting contain elements of the to-be-finished result, be it a landscape or a flower – along with a typology of buildings and descriptions of materials

to be used and figures of story and myth to convey the spirit in which the disposition is to be undertaken and which the result should convey. The basic, recognizable elements are disposed as a relational interaction of forces to produce a new configuration. The *Book of Changes* (*Yi Jing*, or *I Ching*) must be the first such written manual: it divines a situation as an 'image', choosing from a repertoire of images via the throwing of yarrow stalks. Then, by focusing on variations in the image, it produces a possible outcome.

The virtual-real was never a distinction of absolutes in Chinese pictorial tradition. A landscape painting could also be composed as a garden; the vastness of a mountain could be replicated as the lid of an incense burner. Such objects were mediums of transport into what transcends them yet is located within them. And all of this is a counter to the projective, perspectival plan as a guide to building and to the linearity of cause and result that has prevailed in European-based architecture since Leon Battista Alberti's treatise on the subject in 1452.

Rendering differs from the Chinese tradition of disposition in that it puts together elements into an as-if already-built reality, based on already-built reality, around an iconic invention or a copy of a desired building or a copy of a feature of already-built constructions, using a global source-book. It also differs because it is not just a faithful transmission and replication of design elements and their spirit. But the process of rendering in China does deal, as do efficacious dispositions, in the construction of images replicating images, and it abolishes the sequential privilege of the architect's plan. A similar construction of images goes on in the reconstruction of the past for urban tourists.

Memory projects

Heritage is one of China's many thriving industries, attracting mainly domestic tourists looking for authentic, but suspecting fake, relics of the past. Less critically they also look, as tourists do everywhere, for attractive reconstructions of past vernacular architecture, theme parks and the like with modern conveniences and shopping opportunities.

The transformed imperial city in Beijing surrounds the imperial palace, which is a vast museum, attached to which are, as in museums all over the world, shops and cafés. What is stranger is that it is a model for replication. One such copy is in the city of Anyang. In the same city is the archaeological site of a far older city, capital of one of China's Bronze Age kingdoms, such that Anyang boasts of being the ancient capital of the Shang dynasty. The replica of Beijing's imperial city is a mood-setting of the exhibition of the site (see also p. 89).

Authenticity in China, and Japan, has different criteria from those first adopted by UNESCO after the destructions of the war in Europe. Everywhere, including China, preservation of archaeological remains is core. But in China and Japan the original materials are not as central or as sacred as the stones of the ruins of Greece or Rome, or the early Christian churches and cathedrals. Rather, what is emphasized is the continuation of a tradition of building as in the *Principles of Building*; the continuation of a craft, but with less lasting materials.

Many kinds of reconstruction occur. There is the use of old, transmitted crafts to create replicas of old buildings or to add elements of tradition to new buildings. But on very old archaeological sites there are attempts, in the absence of handbooks, to reconstitute what the sites must have been like. This can be done with close reference to the remains, or without anything more than looking like a generic past. The remains can thus be surrounded by theme parks.

The use of transmitted crafts reproduced the exotic in the imperial construction of replicas of the reaches of the empire, in palace parks and hunting grounds, using builders and other experts from the outer regions brought into the centre. The extension of this imperial privilege in contemporary China is as remarkable as is the speed of urbanization. The faithful, museum-like theme parks and the simply old-looking past as exotic are enjoyed as holiday resorts, and they are amplified by proliferation of the new and the foreign. There are theme parks with buildings from all over the world, as in Disneylands, but also parks where houses and temples of China's minority nationalities are inhabited with residents and performers of ritual music and theatre dressed for the part.

In every large city there are 'old streets of replica antiques' (*fang'gu jie*), bars, boutiques and appropriately styled restaurants, where 'old' can be anything from the first half of the twentieth century to the earliest eras of history, each case making a claim to special fame. The redevelopment of Xintiandi, in Shanghai, kept many of the old French Concession buildings and a few of the Chinese alley-buildings and turned them into restaurants, cafés, boutiques, hotels and expensive brand-name shops. As with the destruction of old areas and their reconstruction as old-*style* areas, the residents that had been the life of these neighbourhoods have been relocated. Xintiandi was undertaken by the Hong Kong property developer Victor Lo, and his various companies, in close profit-sharing alliance with the urban district government, which in turn employed further companies for the destruction of districts and the relocation of residents – a typical system of sub-contracting to deflect accountability and responsibility, not just in China but also in the USA, the UK and many other countries. The profits were enormous since the companies' purchase price from the

municipality for land-use rights was fifteen times less than their value ten years later. It became the model for similar deals in many other cities in China, by the same developer and others. New urban alley areas, such as Dashila, Houhai and Drum Tower in Beijing, or Ciqikou in Chongqing, have had the same treatment, raising real-estate prices and creating districts whose goods and services can only be afforded by high-income earners.

In Chengdu, the capital city of Sichuan Province, there is a heritage area at the south of one of its parks, adjoining the ancient tombs of Liu Bei and Zhuge Liang, two heroes of the third- and fourth-century Three Kingdoms period and the subject of many poems, plays and stories. The tombs are well restored and kept. The surrounding area, though said to be in the style of the kingdom of Shu, whose capital was uncovered near Chengdu in 2001, is in fact a pedestrian precinct of shop-houses and restaurants, including a very tasteful Starbucks in a mansion of garden courtyards all built in the last twenty years. Its style is similar to anywhere in China that has reconstructed 'old' streets mimicking the look of late imperial dynastic-era markets. It is a place for local and foreign tourists, and the delusion of being in the style of the ancient kingdom is easily tolerated. These developments are without doubt a great draw, but the pleasures of being there hide the pains of those who have been dislocated from there [8].

The most ubiquitous urban reminders of a generalized Chinese past are in the parks and green spaces beside highways and within housing projects. These are sprinkled with the same features from Chinese gardens and ceramics that were copied in Western gardens and blue-and-white china in eighteenth-century Europe: the pavilion (or gazebo), the curvy bridge or pergola, the wall with differently shaped windows and fretting, and the curved roof. Property developments, including those for residents relocated from the more expensive central city areas, usually include gardens with one or more of these features to provide spaces for walking children and meeting neighbours.

Everyday appropriation and its expropriation

Some of the older intimate places have not been destroyed, but they are less visible, such as this one in Shanghai [9], overlooked by a new high-rise in the distance. In the new spaces, however, filling and moving through the alleys and squares of housing projects are other meeting points, in which the displaced residents create a sense of belonging around market and food stalls. Unregulated snack and food stalls humanize the planned spaces of sidewalks at and on the pedestrian bridges over the six-lane boulevards or at the gates of estates of apartment blocks. Here, too, are the scavengers with moto-trucks, more efficient recyclers than the municipal sort-bins in which unsorted rubbish is thrown.

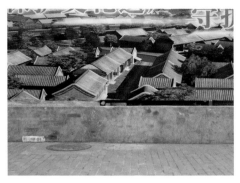

8. Xu Zhengqin, *The Second City, No. 2*, 2007. The slogan over this hoarding of courtyard houses and alleys says 'Preserve our cultural heritage', which has been destroyed in order to be reconstructed.

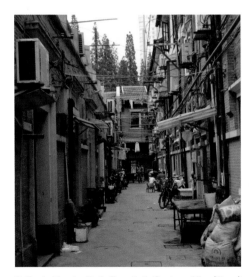

9. Paula Morais, *Early Twentieth-Century Alley* (lilong) *in Shanghai*, 2012. In this urban alley-way, people sit outside their doors and look after children as they talk.

Ultra-modern constructions are also humanized. As with all new monuments that add to the city profile, residents appropriate them with nicknames. The headquarters for the national television broadcaster, CCTV, designed by Rem Koolhaas, is nicknamed 'Big Pants' (*da kucha*). It is a geometric composition of space among the vertical dividers that can be seen from the third ring road of slow-moving traffic and the supports of overhead concrete swoops, their angled beams and the curves of the traffic lanes. Motorist commuters pass through these recompositions of the centre of the city's gravity toward the east. Another view from the fourth ring road – and the whole girding of the city by ring roads – takes in the 'Bird's Nest' Olympic stadium by Herzog & de Meuron, itself an image of inhabitation within a constantly changing set of different buildings, but also reconfirming the older north–south grid of the imperial capital.

These are the spectacularly visible fronts of the modernizing regime of visibility. Their counterparts, equally visible but low-rise, are the memory projects. Between them they proclaim the high civilization of China and its new global presence. Far less visible are its builders, most of whom are rural-urban migrants. These builders of the high-rises are equivalent to the Native Americans who specialized in the trapeze artistry of skyscraper scaffolding, moving from one site dormitory to another, saving a little from their wages to send to their fixed rural homes. These builders are also the destroyers of the old homes to create the great wasteland sites where nail households once stood and where sometimes villagers have managed, provisionally, to preserve their temple [10].

Conclusion

In this regime of visibility, urbanization is a top-down construction of what planners, policy makers and developers, alongside both new and old city dwellers, consider modern civilization to be. It is literally the creation of a vision, through the fanciful names of estates supplied by developers or through the profiles of iconic buildings such as the 'Bird's Nest' stadium. Despite becoming a foreign architects' playground, and despite the pastiches and recompositions of rendered city complexes, urban China is distinctly Chinese in several ways, beside the very speed of urbanization and the widespread scope of its visual references. One is the fact that urbanization is also a project of re-housing that has deliberately involved an increase and an improvement of living spaces, from the most basic (inclusion of kitchens and lavatories in apartments) to the most luxurious (creation of garden estates of semi-detached or entirely detached villas with huge living rooms), in an era of urban planning that started from conditions that were often wretched though not nearly as bad as the conditions of the European poor when modern planning began. Another is the obvious fact of heritage projects that celebrate a sometimes homogenized and generalized, sometimes archaeologically visible, Chinese past. A third is the combination of all this: the whole cityscape with its street furniture, including government slogans, which is a context that appropriates all the borrowings from abroad and from other Chinese cities. A fourth is the humanizing reality detail supplied by the various appropriations of urban space by its residents – grandmothers walking their grandchildren, amateur musicians playing in parks, formation dancers performing in public spaces, big-brush and small-brush calligraphers working with evanescent water on park paving stones – and market traders and food stallholders on unregulated lots selling fresh produce or breadsticks and soymilk for breakfast. Finally, this is an urbanization characterized by two contrary features: gigantism and lack of maintenance. One enduring image of this was the mesh of flat struts, the twigs of the 'Bird's Nest' stadium, being polished by migrant worker 'bird-men', as onlookers called them, before the stadium opened, because of Beijing's polluted air.

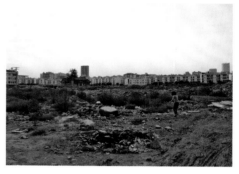

10. Hans Steinmüller, *Ready for Development in Kunming*, 2013. Local residents of Kunming forced developers to leave their temple – now surrounded by wasteland – untouched.

1.
Ephemeral Cities

Demolition and construction
in Chinese urban development

During the early development of the People's Republic of China (est. 1949), the cities were industrialized and countless examples of dynastic architecture disappeared. By the 1980s, for example, the image of the capital Beijing had been reshaped by more than 14,000 industrial chimneys, newly erected across the city. When Mao's Cultural Revolution was at its peak, between 1966 and 1969, the situation grew worse. The Red Guards (*hongweibing*), who claimed to be the 'critics of the old world', started to smash the 'Four Olds' (*sijiu*: Old Customs, Old Culture, Old Habits, Old Ideas), in a practical expression of the establishment of a new world. Early in the morning on 19 August 1966, some 300,000 teenagers rushed onto the streets to confiscate and eliminate all the 'Olds' across Beijing. Public property and cultural relics were attacked and numerous historical treasures were destroyed over the course of a few weeks. Records indicate that by the end of the Cultural Revolution, in Beijing alone, 4,922 of the 6,843 officially designated 'places of cultural or historical interest' had been demolished – by far the greatest number of them during August and September 1966, the darkest summer in the history of Chinese culture.[1] After Deng Xiaoping initiated the Open Door policy in 1978 to encourage foreign investment, ironically everything changed once again. The visual legacy of Mao's era was itself swept away through the new development of the country, on the one hand to offer a new image of China to sustain economic growth and on the other possibly to remove people's traumatic memory of the Cultural Revolution.

According to a recent report, 'China is pushing ahead with a sweeping plan to move 250 million rural residents into newly constructed towns and cities over the next dozen years, a transformative event that could set off a new wave of growth or saddle the country with problems for generations to come. The government, often by fiat, is replacing small rural homes with high-rises, paving over vast swaths of farmland and drastically altering the lives of rural dwellers... The goal of the government's plan is to have integrated 70% of the country's population, or roughly 900 million people, into city living by 2025, double the number today.'[2]

As Chairman Mao taught, 'No construction without destruction' (*bupo buli*): an axiom for his Cultural Revolution half a century ago, but also a prophecy for the dramatic urban developments of today. Construction in China does not merely constitute an effort towards improvement; it is a revolutionary action fundamentally to replace the 'old' with a completely 'new' visual experience. Over the last thirty years, buildings, complexes, streets, even entire urban structures have become transitory – removed, reconstructed or replaced – offering little trace of what went before. For many this is cause for celebration; for others it generates grave concerns. For artists who have witnessed the transformations, it offers an opportunity to tell stories through personal reflections.

The artist Shao Yinong (b. 1961) and his wife, Mu Chen (b. 1970), with a background in photojournalism, decided to make photographic records of all the Chairman Mao statues across the country before they disappeared. The series, dating from 2003, features panoramic views of all kinds of squares, located either at the centres of cities or of work units (*danwei*, a Socialist term pertaining to state-owned enterprises) such as factories, universities and train stations. In China, 'every city, town or village must have a square for public gatherings, big or small; a square is always conjoined with a platform built for the leaders to review the mass assemblies. A square thus becomes a legitimate place for people to meet their leaders, an indispensable joint between the high and the low, the brain and the body.'[3] Within these squares, there is inevitably one thing in common: the statue of Mao. The design of the sculpture has varied over the years, though the version with right arm raised high in the air was set as a typical model during the Cultural Revolution. The statue was to be replicated and placed in various locations, for example Zhongshan Square in Shenyang and Shengli [Victory] Square in Changchun [11, 12]. Each of the photographs was further developed by hand-tinting. This technique was popularly applied to black and white photographs during the first half of the twentieth century, and the use of the specialist transparent pigment, with its limited range of colours, shaped a particular aesthetic taste in photographic imagery for several decades. The artists' rendering of the city squares leads to confusion: based on the techniques employed, one is not immmediately sure whether the photographs are contemporary, were taken during Mao's 1960s, or were produced in the 1920s or '30s. In fact, the reality is even more confusing. The surroundings of each square have been constantly reconstructed, with new road layouts, architectural complexes, advertisement signs and neon lights, yet – in entirely different environmental contexts – the image of Mao remains the same, still waving to new generations.

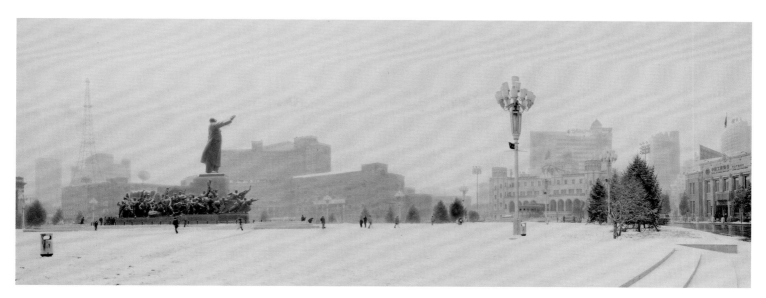

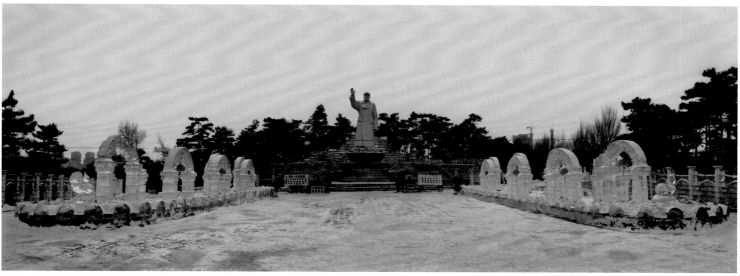

11. Shao Yinong and Mu Chen, *The Square:
Zhongshan, Shenyang*, 2004

12. Shao Yinong and Mu Chen, *The Square:
Shengli, Changchun*, 2004

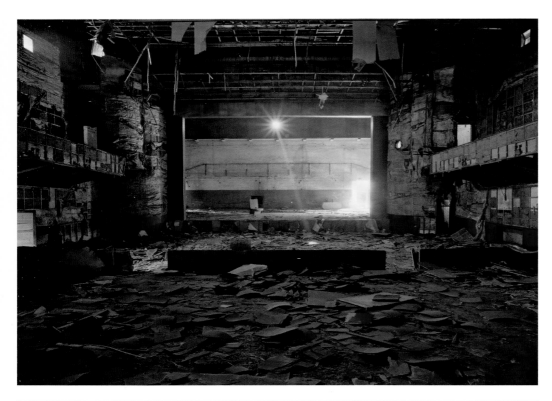

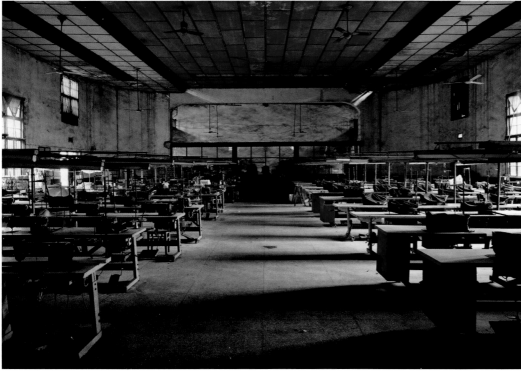

The boundary between documentary and art is also blurred in Shao Yinong and Mu Chen's series *Assembly Hall (Dalitang)*, in which the viewer can perceive only the simplest execution of photography and the most minor artistic intervention. Setting out from Yan'an, the artists travelled for over two years to locate hundreds of revolutionary shrines and assembly halls built since China's revolution. As the most communal space in a community, where masses gathered for events of either celebration or criticism, assembly halls played an important role in the Cultural Revolution. 'It was a stage where one could have acted as a hero with dignity and then suddenly become a guilty counter-revolutionary,' Shao Yinong has noted. 'It was once filled with glory and humiliation, happiness and agony, passion and violence, resounding with enthusiastic and hysterical voices, but all has passed today.'[4] Some assembly halls have fallen into ruin; some have survived, complete with Mao's portrait on display; others have been converted into warehouses or factories [13, 14]. One thing that has never changed is the red star centred at the top of each façade to mark the revolutionary vision [15]. Although often eroded away over the years, these stars seem to have grown into the walls, like heroic scars on architectural bodies. As if to confront the threat of the new urban development, they appear determined to guard the spiritual homes of past generations … at least until the last minute before the earth-movers start to rumble.

(opposite above)

13. Shao Yinong and Mu Chen, *Assembly Hall: Shenbian*, 2002

(opposite below)

14. Shao Yinong and Mu Chen, *Assembly Hall: Anyuan*, 2002

15. Shao Yinong and Mu Chen, *The Star: Xiajia*, 2008

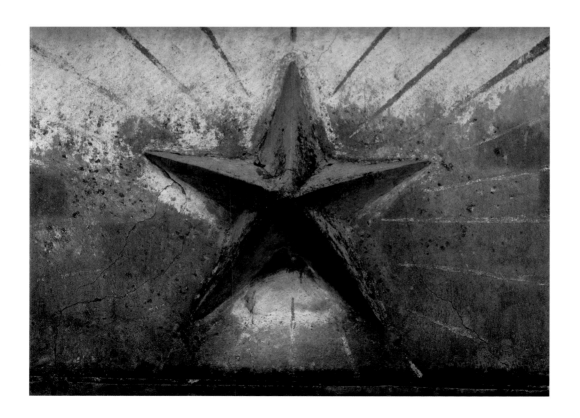

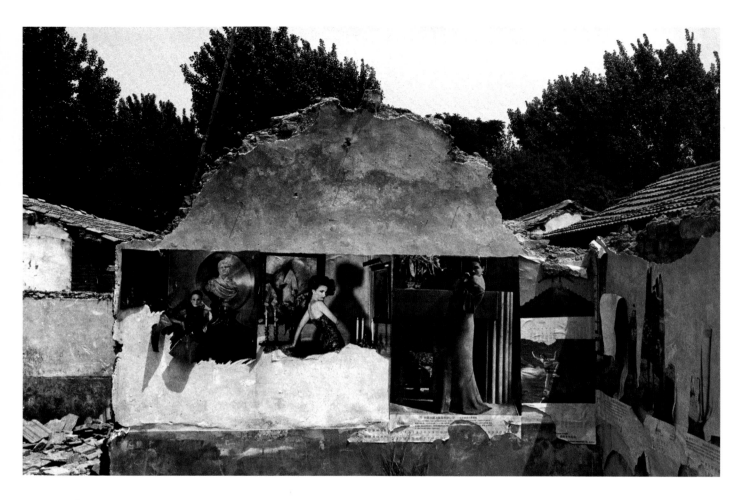

16. Rong Rong, *1996, No. 10a*, 1996

Numerous old residential houses were also unable to survive the determined strategies of urban development. For Rong Rong (b. 1968), who migrated from the Fujian countryside of southern China in the 1990s, the experience of Beijing – one of the world's fastest developing cities – was breathtaking. Unlike his hometown, which enjoyed a relatively steady pace of life, construction and destruction in the city were everyday experiences. Rong Rong was above all struck by the spectacle of ruins. From 1996, he began to focus on demolished houses in the city. These were empty, but for torn pictures still attached to shattered walls [16, 17]. Now the centre of attention, these portraits – mainly of women, either recognizable or unknown, some perhaps movie stars or fashion models – became the only evidence of the private lives once lived in the spaces. 'Like any representation of ruins, the subject of the photographs is the absence or disappearance of the subject. But

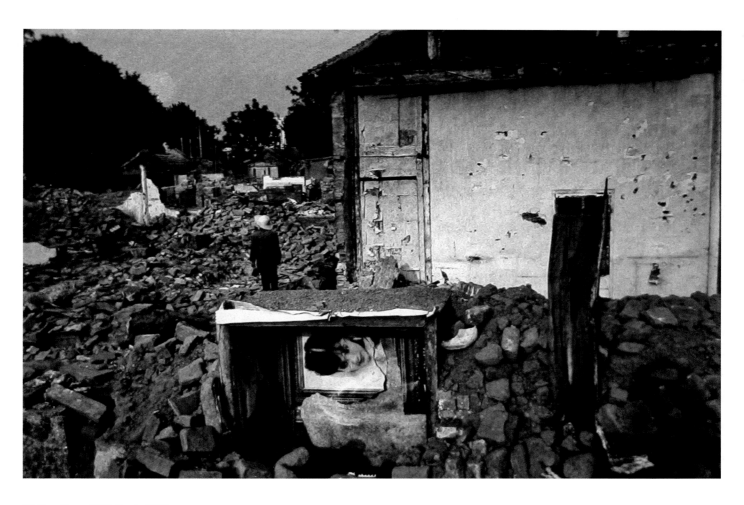

17. Rong Rong, *1997, No. 1a*, 1997

Rong Rong fills the vacancy with *images*,' notes art historian Wu Hung. He continues: 'Torn and even missing a large portion of the composition, these images still exercise their alluring power over the spectator – not only with their seductive figures but also with their seductive spatial illusionism. With an enhanced three-dimensionality and abundant mirrors and painting-within-paintings, they transform a plain wall into a space of fantasy, even though this wall is all that is left of the house.'[5] These vulnerable fragments of pictures abandoned in empty houses do not serve to make the spaces appear fuller (though they certainly enrich the images); on the contrary, they highlight the emptiness by implying the past lives that once filled the spaces. In fact, the spaces are now more than empty; they appear to have been turned violently inside out. They are naked.

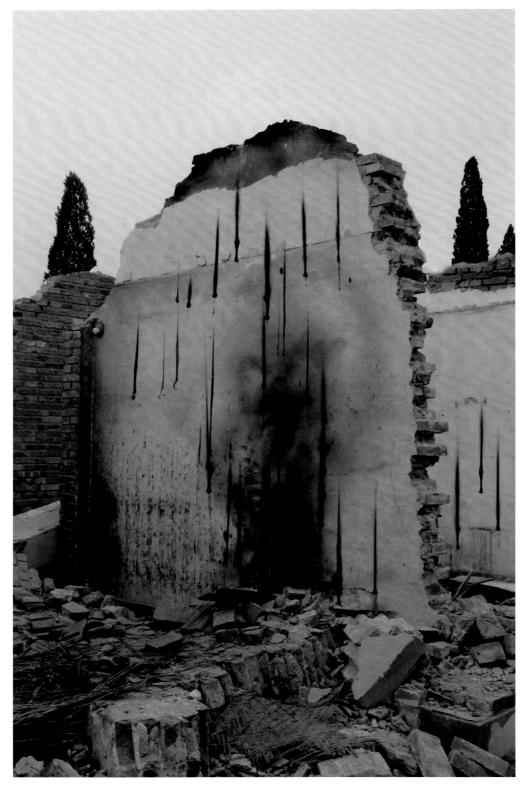

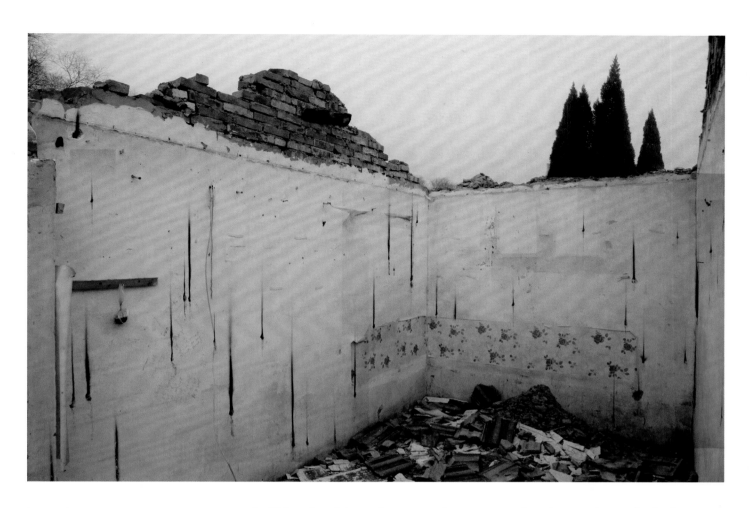

(opposite)

18. Shao Yinong, *A Century's Dream,*
No. 2, 2014

19. Shao Yinong, *A Century's Dream,*
No. 4, 2014

In China, demolition and reconstruction never cease in order to make way for further urban development. In 2014, Shao Yinong searched destroyed residential areas, including some relatively new ones that had only been in existence for a few decades, for his site-specific work *A Century's Dream* [18, 19]. The desolation presents a turning point, marking the end of one living environment and concurrently the inhabitants' departure for a new lifestyle; for the artist, it also represents the final traces of the city he once remembered. He drilled holes in the remaining walls of the houses, some of which may have partitioned off living rooms or bedrooms. He then inserted mugwort plants into individual holes in order to burn them, as if performing a ritual for the past and the future. In Chinese tradition, it is believed that mugwort can exorcise evil spirits. Here, they are used just once, ephemerally, to leave burnt marks, naturally streaking upwards and melding with the sweet, homely patterns of the fragments of wallpaper. The photographs do not show us the process of the burning, nor do they convey the fire or the smell; they show only the result – the smoke, or the traces of the living fire – just as the architectural parts survive for now to manifest the existence of the past. These traces, in the artist's view, form 'a ruin of lives and a graveyard of hope'.[6] They are ruins piled upon ruins, using the disappeared to commemorate the disappeared.

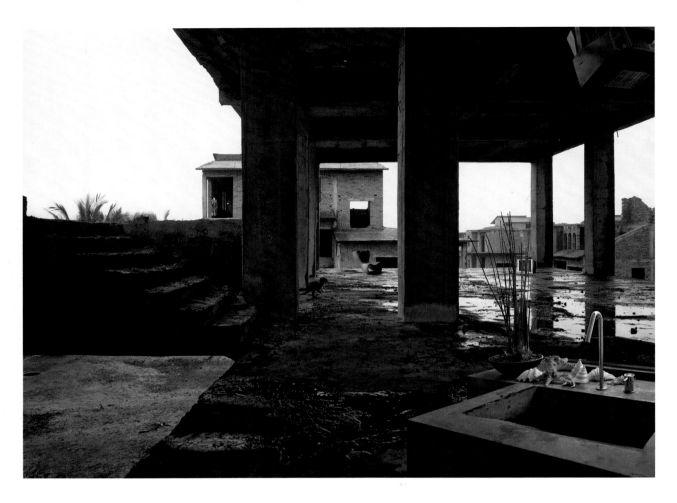

20. Wang Chuan, *Wasteland: Empty Mansion*, 2006

Unfinished buildings (*lanwei lou*, literally 'buildings with rotten tails') are another kind of ruin – this time, made by construction rather than destruction. As urbanization progresses, construction work may for various reasons be delayed or halted at some stage of the development, leaving sites abandoned. Near the city of Haikou, the capital of Hainan Province, for example, a large area of unfinished construction was captured by Wang Chuan (b. 1967) in his 2006 series, *Wasteland*. As the title indicates, the original plan to create residential areas was a failure, with the incomplete architectural structures that once signalled a brighter future soon becoming dilapidated and 'rotten'. These spaces, although uninhabitable and unloved, have been turned theatrical through the

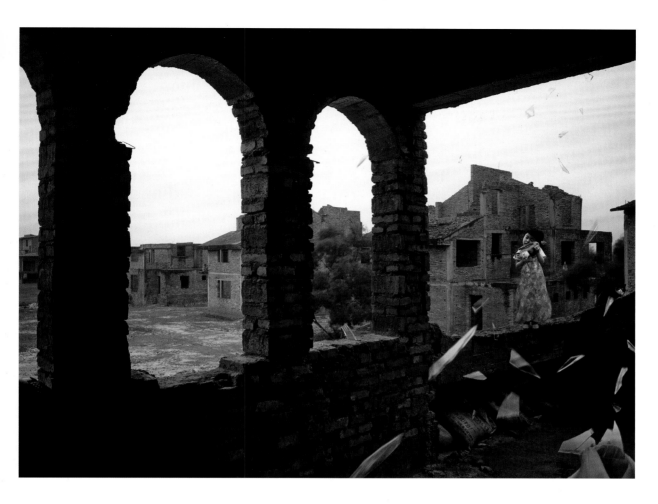

21. Wang Chuan, *Wasteland: Windy*, 2006

artist's visual narratives, supported by digital technology. Solitary items of furniture in trendy designs, televisions, plants and other home accessories (though nothing essential for living) lie scattered, no longer suggestive of model homes or a better life [20]. One image features a little girl peacefully holding a toy while standing on top of a half-finished wall, exhibiting no fear of being alone or of being in danger … as fragments of glass rain down [21]. The unfinished construction belongs to nobody and yet, as a theatrical stage, it invites all audiences. It no longer represents failure exactly, but perhaps an interval in an absurd drama.

Whole 'cities with rotten tails' can exist, too. In the case of Yumen, northwest of Qilian Mountain in Gansu Province, the whole city once flourished, but within six decades it found itself in steep decline due to various political circumstances. In 1938, the very first oilfield in China was established in Yumen. To meet the needs of the Second World War, it contributed its precious resources to the country, from 1939 to 1949 yielding more than 90% of the total national petroleum production that had brought China into the club of states with oil reserves. With little strategic planning, however, the oilfield was excessively exploited and quickly became exhausted [22]. Since the 1990s, serious problems relating to poor governmental and institutional decisions, regional economics and natural ecology have together led to a social crisis in the area.

In 2006, Zhuang Hui (b. 1963) and Dan'er (b. 1983) began to plan their Yumen project. According to their research, there had been at least ninety industrial enterprises in Yumen in 1996, but just four years later there were only eight left, which had survived through all kinds of difficulties. During its time of prosperity, Yumen had boasted a population of more than 120,000 residents, but by 2007 three-quarters of these had moved, leaving behind the last quarter, many of whom were elderly, retired or disabled. The whole city was overshadowed by an atmosphere of insecurity and fear. Abandoned public facilities, deserted streets and demolished residential buildings could be found everywhere [23, 24].

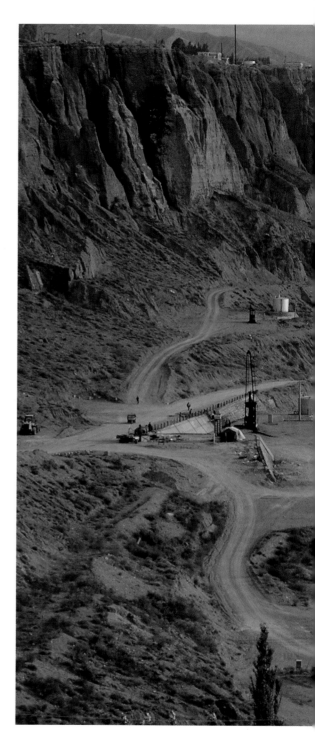

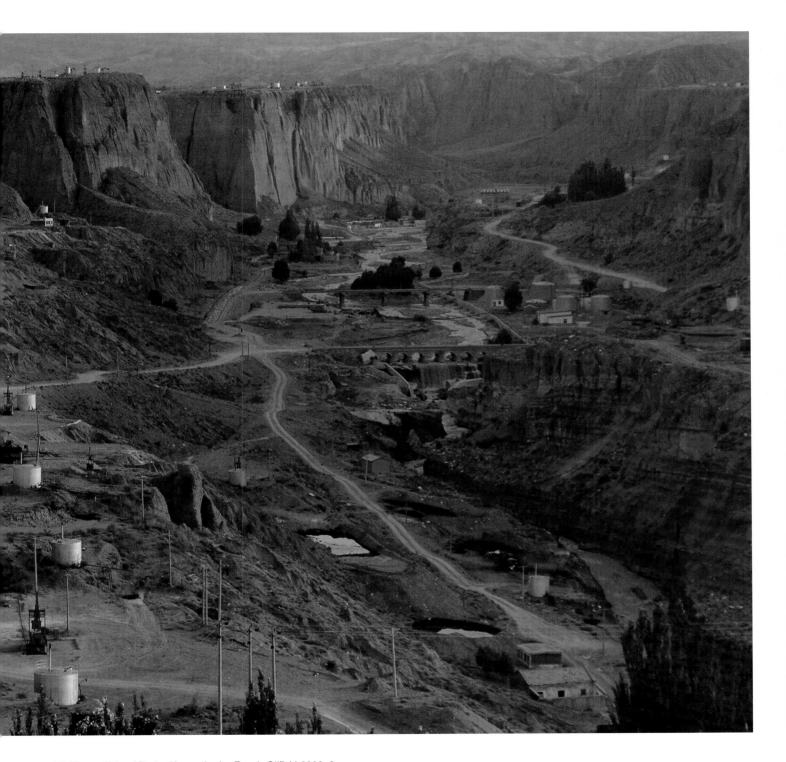

22. Zhuang Hui and Dan'er, *Yumen: Laojun Temple Oilfield*, 2006–9

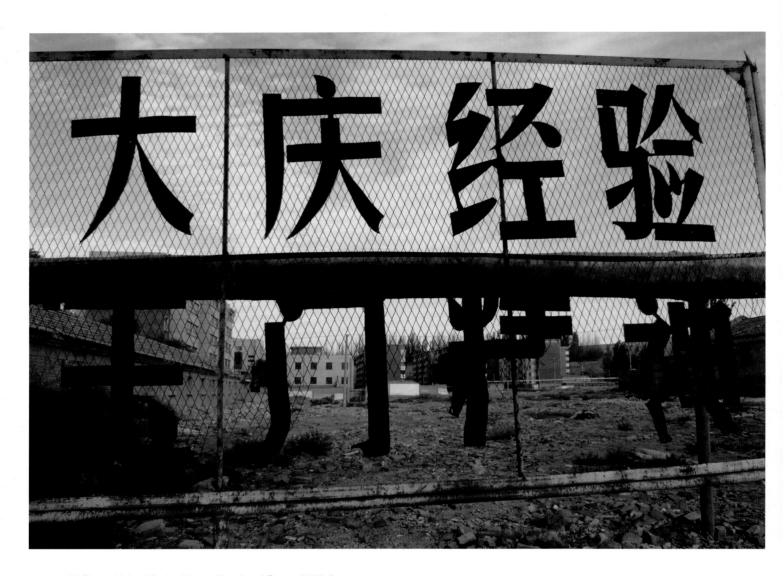

23. Zhuang Hui and Dan'er, *Yumen: Abandoned Factory*, 2006–9

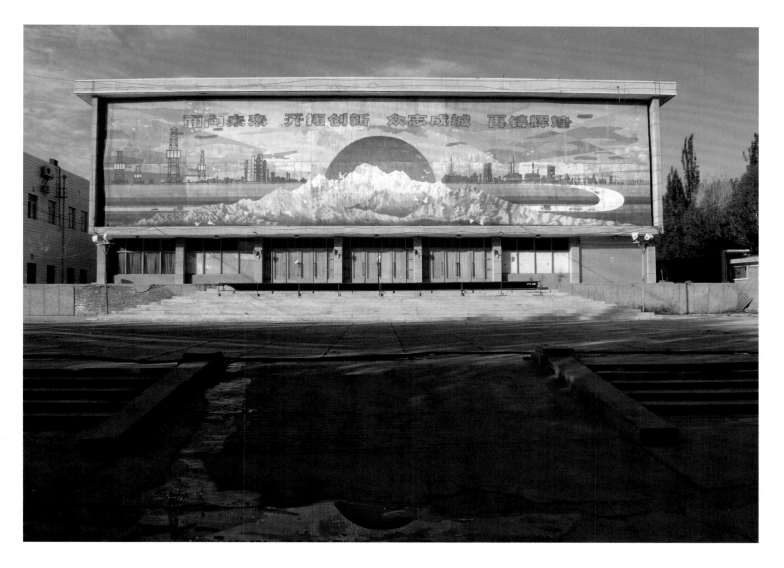

24. Zhuang Hui and Dan'er, *Yumen: Abandoned Theatre*, 2006–9

In 2008, Zhuang Hui and Dan'er set up a photography studio and hired a local photographer to capture the last expressions of Yumen over the course of a year before it all disappeared [25, 26]. The studio opened as an ordinary business, and no one was told or realized that a contemporary art project was being produced. The firsthand visual materials collected, as well as the entire process of setting up and running the studio, became part of the artwork, and consequently of course a series of photographs was produced in the studio. Make-up, costumes, props, backdrops and lighting were carefully arranged in order to provide a variety of the commercial services available in any other studio of its kind. Identification photographs, family and group portraits, and artistic photographs were collected with the aim of examining popular styles and aesthetic understandings within the region. The final presentation of the project makes an obvious contrast. On the one hand, the prosperity of the past oilfield boom has irrevocably vanished, and the rotten slogans of 'Yumen Spirit' and the propagandist paintings remaining on the abandoned sites make a tragic story of the recession; on the other hand, beauty, happiness and dreams can still be fabricated, and even individually tailored, in the photographic studio. According to the customer's personal preference, they could choose to be proudly dressed in uniform or in the most up-to-date style of jeans; they could elect to be a princess of the Qing dynasty or of the Brothers Grimm era. They could make-believe that they were at a sunny seaside (without the worry of getting their shoes wet) or in the greenest spring-time garden, as if the depletion of oil supplies and subsequent social problems in the area had never come about. Local residents, styled in their favoured outfits and make-up, were captured within their ideal environments, disregarding anything less bright or colourful outside the immediate frame, their collective gaze posing a confident promise of a better life beyond the depressed surroundings [27, 28].

25. Zhuang Hui and Dan'er, *Yumen: Yumen People's Photo Studio*, 2006–9

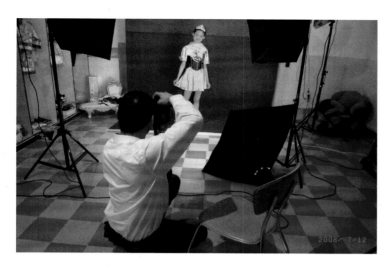

(top left)

26. Zhuang Hui and Dan'er, *Yumen: Photographing in the Studio*, 2006–9

(above left)

27. Zhuang Hui and Dan'er, *Yumen: Group Portrait, No. 2*, 2006–9

(above right)

28. Zhuang Hui and Dan'er, *Yumen: Group Portrait, No. 1*, 2006–9

The achievement of the Yumen project does not necessarily rely on conceptual techniques: methodologically, the artists chose an observational approach to make a direct connection with the community. Twelve months of real life in one chosen area was designated to document naturally the representations of people living through urban transformation. The distinction between the media of photography, performance and participatory art thus remains unclear, as does the nature of the work (documentary record or artistic reflection) and the space between commercial photography studio and artist's studio for generation of the work.

The image of China has never been still. Urban changes are magical enough to confuse not only visitors to the cities but also the residents who are closest to the magicians. Zhang Peili (b. 1957) has been living in Hangzhou for many years. In 1999, he became interested in the newly built main entrance to the Hangzhou Parterre, located on the west bank of the well-known West Lake. The artist set up his tripod on the axis line immediately after the entrance to photograph a symmetrical view of the boulevard leading to the heart of the park [29]. In his initial plan, the work was to be a series of critical reflections upon public sculptures in China, such as the Grecian-like statues standing on both sides of the avenue.[7] The image provides no culturally related visual references: though the plants might seem to be arranged according to a particular gardening aesthetic, the picture could have been taken anywhere. Of course, Zhang Peili knew that this was the Hangzhou Parterre, although the landscape appeared fresh to him. For him, the Western style of the sculptures seemed an irrelevant misplacement in a Chinese park, providing an altogether hybrid environment. However, the real confusion was to occur a year later, when he revisited the Parterre. Of the view at the entrance, there remained not a single identical element. The original boulevard was no longer a boulevard, but instead had been transformed into a square, with a few steps leading up towards a huge parterre in the centre. The Western-style statues had been removed and replaced by a pair of Chinese semi-nudes at the front, probably inspired by the flying apsaras from the Dunhuang murals. From exactly the same position and perspective, Zhang Peili's camera captured a completely different scene. His second visit to the site might not have been planned for any artistic purpose, but the moment at which he saw the complete transformation of the landscape at the entrance was decisive. His original idea of discussing the hybridity of public art was no longer the priority; his new focus became changes in reality. During the production of the work, what was actually *artistic* – the artist's photographic language, or the reconstruction of the entrance and its reappearance? The two photographs taken just one year apart are purely *documentary*, but their juxtaposition makes a remarkable statement. The two separate images – varying in all sorts of aspects, including the layout of the space, the arrangement of the plants, the style of the sculptures and the materials of the pavement – faithfully show a view of a single place.

29. Zhang Peili, *The Entryway of Hangzhou Parterre One Year Apart*, 2000–1

In 1997, Chen Shaoxiong (b. 1962) started to make a three-dimensional photo-collage series, consisting of several levels of images collected from a city, forming a single street view. Rather than utilizing advanced photographic instruments or digital technologies, he made work that looks amateur and almost clumsy. Simply capturing whatever he saw on the street, including pedestrians, vehicles, passengers and traffic signs, he turned his images into three-dimensional cardboard cut-outs, according to the proportions of their sizes, and created rearranged street scenes. As indicated in each image by the deliberate inclusion of a pair of hands, the collages are perfectly portable, to be positioned against new backgrounds of specific urban landscapes [30–32]. By relying on the happenstance of the camera's shutter, Chen Shaoxiong minimized his artistic involvement in the photographic practice, almost inadvertently arresting – or freeze-framing – incessant changes in the cityscape. Each reconstructed photo-narrative offers a miniature theatre, in which an ordinary street view can be restaged. It is excerpted and reassembled from everyday reality; in fact, from the actual background behind itself.

Chen Shaoxiong has said, 'Although I am a resident of Guangzhou, I still have a tourist mentality towards this city. Not just because this city will outlive me, but faced with the daily changes, I often have the feeling of being elsewhere…' Chen Shaoxiong's relationship with the city is patently unclear; photography, for him, is the way to *see* the city. However, he continues: 'I feel that the speed at which I photograph the streets of Guangzhou will never catch up with the speed at which the streets of Guangzhou are changing. I originally wanted to re-create a Guangzhou out of photographs, documenting item by item, object by object… But, because the city is not a static object, the actualization of this desire can only be thoroughly realized in a dream. This is indeed the limitation of a person's temporal and spatial existence. For this reason, I don't dare to leave Guangzhou for long, but this is also a paradox, for my living space has become even more restricted.'[8]

Naturally, there is no possible means (including video) of registering and manifesting every single detail of an urban transformation; as it is, the portability of Chen Shaoxiong's installations, designed to be rephotographed back in reality, suggests clearly the momentum of change as well as the transitory nature of what one sees. Arguably, as critic Hou Hanru discusses, 'Assuming himself as a permanent tourist living in his home city reveals a very important aspect that decisively changes the nature of contemporary cities from mutually separated localities with fixed characteristics to more generic, mutually connected and influenced globalised urban sites with mobility, in both external and internal directions. People not only observe and enjoy cultural differences when they are travelling to other cities. They are also witnessing, participating and consuming new differences in their own localities generated by the process of urban change impacted by globalisation. Sitting at home is no longer an experience of being home. Instead, it's more and more an adventure to travel to unknown places.'[9]

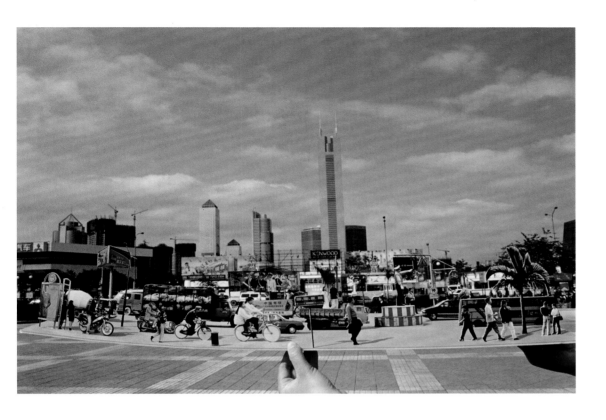

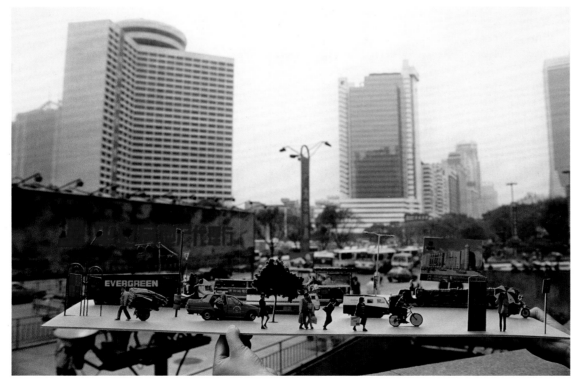

30. Chen Shaoxiong, *Street, No. 1*, 1997

31. Chen Shaoxiong, *Street, No. 2*, 1997

(overleaf)
32. Chen Shaoxiong, *Street, No. 4*, 1997

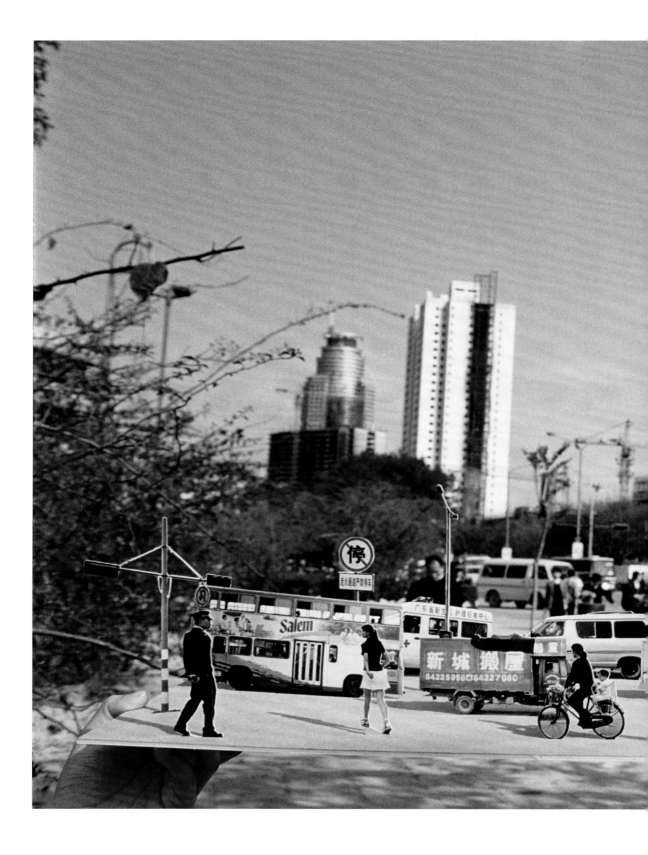

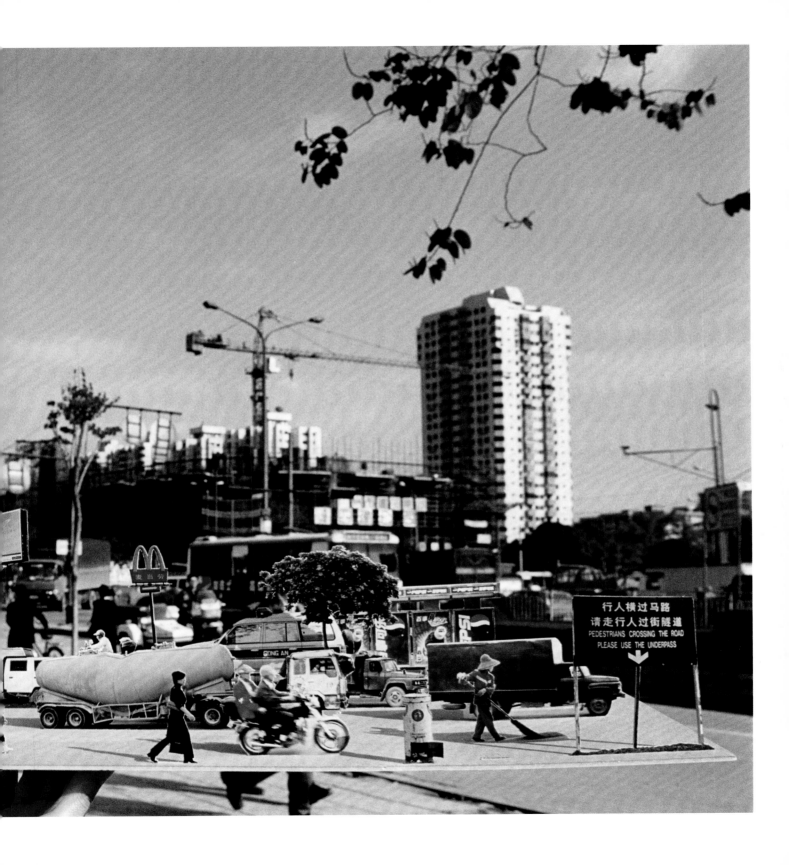

Philosopher, writer and art critic Boris Groys calls the times in which we live 'an era of post-romantic … tourism, marking a new phase in the history of the relations between the urban *ou-topos* and the world's topography'. In his view, rather than individual tourists departing from their places of origin to undertake journeys around the world, it is 'all manner of people, things, signs and images drawn from all kinds of local cultures' that are now on the move. Thus 'the rigid distinction between romantic world travellers and a locally based, sedentary population is rapidly being erased. Cities are no longer waiting for the arrival of the tourist – they too are … starting to join global circulation, to reproduce themselves on a world scale and to expand in all directions.'[10] Chen Shaoxiong's mini street installations highlight not only the dynamic movement of the cities, but also their rapid proliferation in resembling one another: the homogenization of urban appearance in China. Placed against real cities to create double scenes, they literally pose in front of the lens, a humorous expression divulged by the hands of the presenter. It is a truism that, at the end of the day, we are all tourists in this world, for a longer or shorter duration. So cities within China and beyond also come and go, with all the necessary appurtenances travelling alongside as part of the globalization process.

If Chen Shaoxiong intentionally shot everything he saw, looking objectively through a simple, cheap, fast-reacting compact camera, then ten years later, similarly fascinated by urban changes, Miao Xiaochun (b. 1964) made use of more advanced equipment to enhance objectiveness in photographic practice. As the artist reflects, 'We all give priority to the objectivity of photography; however, everyone has to make a subjective choice when they take photographs. We have to choose subject, location and time of shooting, to choose objects to be included in the viewfinder and then to choose or set aperture and shutter speed… Even if we photograph everything, it is nowhere near enough to restore the past… Maybe we do not need to choose at all.'[11]

From 2007 to 2009, Miao Xiaochun and his team spent a year and a half working daily on his ambitious project *Beijing Index*, in which Seitz Roundshot, a fast 360-degree piece of panoramic equipment, played a central role. The artist placed a dense grid of longitudinal and latitudinal lines over a city map of Beijing: each point of intersection identified a location in which to take photographs. Irrespective of locale – busy urban centre or residential area, street, bridge, public space or private interior (fortunately, none of the chosen places was in water) – the photographic equipment was automatically able to produce a full panorama of the location without the need for setting particular angles. The project used several thousand rolls of film, in the artist's words, 'to record the radical transformation of the cityscape, together with its urban culture and everyday life, within a particular timeframe to the utmost completeness'.[12] Although it was decisive for this unique project to be objective and neutral during the artistic (or, rather, non-artistic) execution, still, inevitably, the artist did make the choice – including the subjective decision to propose that particular indexing system – to map out the city of Beijing as

an example and to locate his tripod mathematically to collect future images. Arguably, Miao Xiaochun's choice was methodological rather than visual: in other words, the subjects to be photographed were chosen before they were actually seen by or known to the artist. From one evening to the other, it was always a surprise when the team brought back a set of images documenting the latest appearance of the city. Interestingly, nothing magnificent is shown, such as a landmark image of a Central Business District. Instead all the panoramas present scenes from ordinary life: retirees enjoying the breeze in a traditional-style pavilion, drivers on motor-tricycles waiting for customers who have been unable to find a licensed taxi, builders working together to remove rubble, a quiet antiques market possibly on a weekday, a temporary tent on a construction site, an afternoon nap or card-playing session beneath the gigantic supports of elevated roads, a resting bulldozer and two steamrollers [33–39]. On the one hand, the quantitatively collected visual data can be read as closely representing real life in Beijing: nothing propagandist, nothing personal, but many of the images perceptibly feature a backdrop of on-going urban development. On the other hand, how could one possibly recognize these as images of Beijing? Why not Nanjing, Guangzhou or Shenyang? Without flagship landmarks, it seems that all local identities and cultural distinctions can be interchanged, if not erased, through nationwide urban development. Little individuality is on view in cities that are being rapidly reproduced and expanded. What if the artist were to make an even larger grid over every urban area in China? The panoramas photographed at the intersections may well fail to identify these cities, too, and once again become a visual manifesto of the current urban realities.

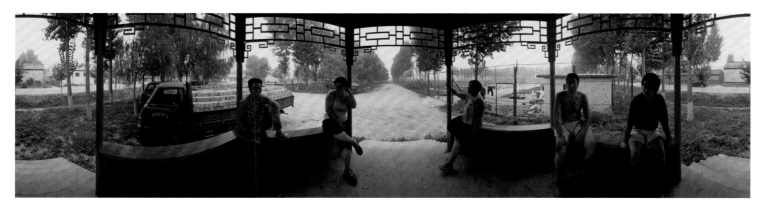

33. Miao Xiaochun, *Beijing Index: R2*, 2007–9

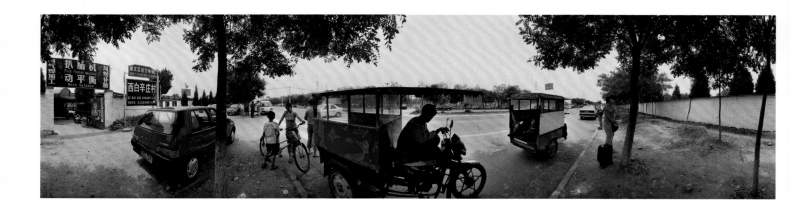

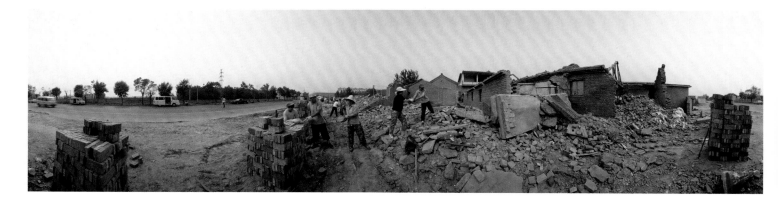

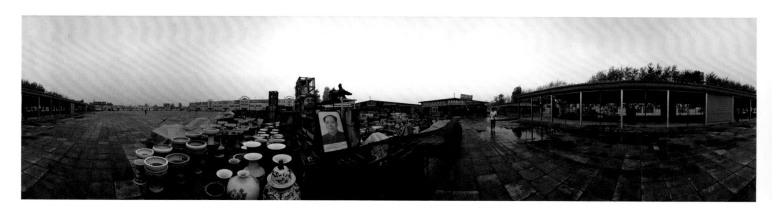

34. Miao Xiaochun, *Beijing Index: A10*, 2007–9

35. Miao Xiaochun, *Beijing Index: B9*, 2007–9

36. Miao Xiaochun, *Beijing Index: B15*, 2007–9

37. Miao Xiaochun, *Beijing Index: D18*, 2007–9

38. Miao Xiaochun, *Beijing Index: N20*, 2007–9

39. Miao Xiaochun, *Beijing Index: N24*, 2007–9

40. Wang Qingsong, *Skyscraper, No. 1*, 2008

Wang Qingsong's (b. 1966) *Skyscraper* depicts the process of constructing an outdoor installation in Changping County, 30 miles north of Beijing [40]. The finished structure is 35 metres high, with a diameter of 45 metres (115 × 148 ft), built solely by the manpower of a total of more than forty construction workers, over the course of a month. The surrounding area still seems to be underdeveloped, or at least not yet urbanized. The outline of thousands of gold-painted iron scaffolding poles gradually and gloriously takes shape among the grouped rural bungalows, while in contrast the plain sandy land seems to be afflicted by the invasion of the skyscraper. As the artist points out, 'The slogan we hear all the time these days is "A New Countryside", meaning the promise of a new life for those living in the rural places … as life in these city outskirts will be better, richer, and every countryside dweller will one day soon enjoy the comforts of urban life, with the same high standards of living. In order to build this "New Countryside", farmers in areas close to cities are encouraged to use their land to build new houses rather than to farm, or simply to leave for work in factories in the cities.'[13] Conceived as a video piece, *Skyscraper* shows the structure developing, but any appearance of the scaffolders has been completely eradicated from the moving image. In order to achieve this, the installation had to be constructed little by little, a pole at a time, by scaffolders who must have had to clamber up and down to allow for the slow progress of the shooting. On the one hand, as the artist has noted, the omission of the builders points to the fact that China's urbanization is heavily reliant on the contribution of workers who are largely migrants from poor rural areas and who ironically are unable to afford to live in the buildings they themselves have constructed. On the other hand, the omission leads to the curious impression that the structure is animated and has grown all by itself in the middle of nowhere. The month-long labour is compressed into a one-minute clip within the video. The manpower remains unknown, until the photographic version of the work reveals the authors of the miracle [41]. In the chosen scene, nearly twenty builders are on site, working collectively to manifest the scaffolding as a specimen of all high-rises. No matter how glossy and grand, it is still hollow, insubstantial, like a mirage in the desert, dissolving once we blink away our illusions.

For Jiang Pengyi (b. 1977), an artist from a relatively undeveloped town in southern China, large cities like Beijing generate a platform to reflect on the notion of home (see also p. 130), but they are also entities that never stop transforming themselves. Buildings and whole areas can be replaced by different sets of architecture, with higher structures, shinier glass walls or cleverer designs for innovative looks, globalized (or Westernized) tastes or political correctness. And yet these can themselves be succeeded once again, very quickly. While working as a photographer for a real-estate company in Beijing, Jiang Pengyi began to focus on newly built high-rises containing apartments, offices and shopping malls for advertising purposes, and gradually amassed a visual collection of urban constructions. These became the key resource for his 2006 work *All Back to Dust*, which presents disturbing images of urban disintegration [42–44]. Real-life residential

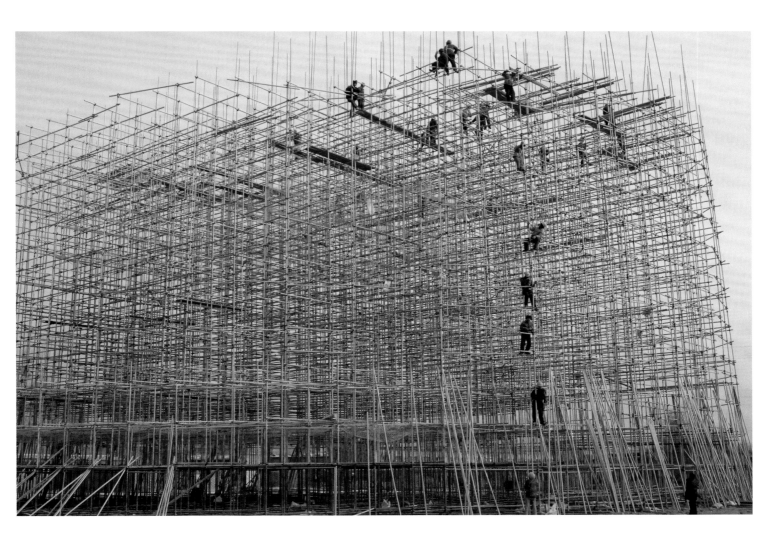

41. Wang Qingsong, *Skyscraper, No. 2*, 2008

blocks have clearly been turned into miniatures and destroyed in a wilderness of rocks and weeds. Some of the structures have fallen down, some are broken or distorted, and some are still on fire, as if following a natural disaster. But no rescue is required: these buildings have already been abandoned. Even architectural landmarks have been discarded among the junk, including, recognizably, the towers of the China World Trade Centre or those more recent urban achievements, the National Centre for the Performing Arts (the 'Huge Egg') and the National Stadium (the 'Bird's Nest'). Notably, the 'Bird's Nest', which opened in 2008, would still have been under construction at the time the work was produced. The artist could not wait to show us an imagined future – one that is singularly depressing but, more importantly, one that overrides the imperative of rapid urbanization by explicitly illustrating the ephemerality of our urban reality through powerful apocalyptic visions.

42. Jiang Pengyi, *All Back to Dust, No. 1*, 2006

43. Jiang Pengyi, *All Back to Dust, No. 2*, 2006

44. Jiang Pengyi, *All Back to Dust, No. 6*, 2006

2.
The Otherness of the Real

Shaping a reality beyond the ordinary urban environment

The constant changes in contemporary China have caused the presence of a reality beyond the ordinary, tangible environment. This reality stimulates photographic practice, challenging artists – particularly Chinese practitioners, who are themselves experiencing the process of transformation – to discover 'visible' changes and to 'see' them differently. The writer Shi Jian points out that 'China's urbanization today has never been experienced before during human history and has been termed "super-urbanization" (*chaosu chengshihua*), disregarding the geographical, architectural and cultural context of the cities'.[1] Western architects have been invited to plant their inventions in the major cities of China, which to many may be a particularly 'foreign' country. In Beijing, for example, new landmarks sprang up rapidly at the time of the 2008 Olympics, including the 'Huge Egg' National Centre for the Performing Arts designed by Paul Andreu and the 'Bird's Nest' National Stadium by Herzog & de Meuron. Rem Koolhaas's China Central Television Headquarters had appeared earlier, in 2002, and Terminal 3 of Beijing Capital International Airport by Norman Foster in 2003. All these constructions helped to create a desired image of the city.

If photographs can 'give people an imaginary possession of a past that is unreal',[2] then the present life in China – which could rapidly turn into a 'past' – urges photographers and artists to arrest the 'past' in order to better understand the present. Contemporary photographs of urban China can often offer a quality of ambiguity as regards the real and the unreal. Especially as we enter a post-photographic era, digital technology lends its advantage to further artistic involvement and critical thinking encompassed in visual narratives. As the architect and urban designer William Mitchell has stated: 'We must face once again the ineradicable fragility of our ontological distinctions between the imaginary and the real, and the tragic elusiveness of the Cartesian dream. We have indeed learned to fix shadows, but not to secure their meanings or to stabilize their truth values; they still flicker on the walls of Plato's cave.'[3] In China, with or without digital technology as an additional instrument, the dramatic conflicts, struggles and triumphs inherent in the country's on-going urbanization are central to the artists' reinterpretations, and the 'inactuality' of everyday life is a mine of inspiration.

Since 2001, Miao Xiaochun has used his camera to reflect the intensive urban changes in Beijing. In one work, he explores the strange reality presented by the 'Huge Egg', abruptly landed, like a UFO, on the north–south axis of an ordinary *hutong* (alley) in a traditional residential area [45]. The modern structure seems so incompatible with the business of ordinary daily life: too big, with nowhere to hide, like an uncouth monster, embarrassingly exposed in public. 'If collective fanaticism was political during the era of Mao, it turns out to be economic after the Open Door policy,' comments the artist. 'One can feel extremely lost, either abandoned by the revolutionary movement of the past

or lagging behind the urban development and economic growth of the present.[34] In his wall-filling work *Celebration* [46], Miao Xiaochun's digital skills discreetly maximized the number of participants attending an opening ceremony for the SOHO real-estate company. To represent an enormous celebratory assembly in a contemporary cityscape, he developed the work from more than ninety individual shots. Repetitive details can be discerned through a careful reading: for example, a group of workers with yellow helmets can be seen to surface in several different locations. For Miao Xiaochun, photography can hold on to a single moment, but also a longer span of time. In another photographic narrative, *Surplus* [47], two differently styled and functioned constructions are juxtaposed next to one another: on the left a disco club with a fashionably Westernized façade, and on the right a Chinese restaurant with a traditional appearance – an imitated modernity versus a fake tradition. In this instance, the location of the two buildings has not in fact been artistically or digitally manipulated; it is real. However, the technical refinements of digital photography have allowed the artist to come close to the possibilities of human vision in re-interpreting the details of image (unlike the human eye, which can direct the gaze towards objects at different distances to bring them into focus, photography usually works with a fixed focal distance). As writer and curator Gregor Jansen explains: 'By combining numerous photographs digitally at the computer, Miao simulates the eye's way of working, simultaneously destroying the illusion of an authentic representation of reality.'[5] To really immerse oneself in these theatrical events, one could further explore and imagine the stories taking place inside each window and the ways to consume the 'surplus' energy and fervour of the day.

(below)
45. Miao Xiaochun, *Theatre*, 2007

(opposite)
46. Miao Xiaochun, *Celebration*, 2004

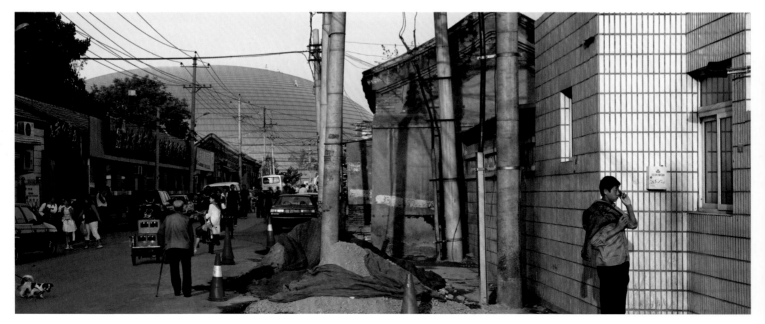

47. Miao Xiaochun, *Surplus*, 2009

The staging of the 2008 Beijing Olympics – a multi-trillion RMB-worth project – included a significant amount of urban development aimed at 'spectacularizing' the city for an optimal presentation on a unique international platform. Mu Chen's series *Landscape as a Will* was a personal reflection, with a nostalgic mood, on this 'beautification' of the city. In the series, the artist did not focus on dramatic scenes but instead on quiet, unnoticed places, particularly those that somehow retained a lingering *literati* flavour of a traditional China. A calm pond with poetically scattered lily pads is captured in the stillness of night. Nonetheless, the artist notes, even this meditative spot cannot offer a reclusive space or any spiritual representation of the individual, when it has been invaded by the glaring reflection of the Beijing television tower [48, 49]. Perhaps only photography can freeze such a strange silence, an unreal moment in the life of Beijing, where public was once able to turn private. Here, dynamic urban lives and their incessant sounds are just a few inches out of shot. Similarly, beneath the elevated roads of Beijing, at the corners of underground passes, trees and rockeries have been arranged to mimic a *literati* garden style, nestled beside enormous concrete structures and industrial street lamps [50, 51]. For the artist: 'This is an epitome of our urban reality. When we are incompetent to establish a vigorous aesthetic for contemporary life, traditional *literati* landscape is imposed on the urban environment as excrescent ornamentation. It is no longer a matter of humanistic concern, but of making artificial miniatures to decorate the concrete jungle. Behind the construction of such urban spectacles, there is nothing but the political will of the state and its expanded power.'[6] In her attempt to revert these locations back to meditative spaces and to recapture an original sense of peace, Mu had to wait on-site for hours to apprehend even one second's moment of quietness. The absence of pedestrians and vehicles is tinged with a desolate air in order to emphasize the landscaping (still the least noticeable aspect of each image) as a poignant reminder of passing tradition.

48. Mu Chen, *Landscape as a Will, No. 10a*, 2008

(opposite)
49. Mu Chen, *Landscape as a Will, No. 10b*, 2008

(opposite)

50. Mu Chen, *Landscape as a Will, No. 2*, 2008

51. Mu Chen, *Landscape as a Will, No. 6*, 2008

The eight great sites of Beijing (*yanjing bajing*) were initially identified during early Jin dynasty times, in the late 12th century. They were modified over the years and finally endorsed by Qianlong, 18th-century emperor of the Qing dynasty, to best represent the temperament and verve of the imperial city. The original sites no longer exist: they have either been removed or rebuilt, and can only be re-envisaged through historical literature. When Wang Chuan visited the eight locations to photograph what could be seen there in modern times [52, 53], he was attracted by the vast discrepancies between real life and historical description. 'As a growing modern metropolis,' the artist has stated, 'for every change it experiences, Beijing can never break away from the links to its long and rich history… The more radical the changes are, the easier such links are to be appreciated. As a result, I am frequently trapped in a rather conflicting situation: while recognizing those new things, as well as changes brought about by the social development, I cannot help feeling confused about the changes accompanying such development. Many things that used to help us find the links between the outside world, the past and ourselves are disappearing or being replaced. Though I live in this city, it seems that I have not become more familiar with it as time passes; instead, I am obsessed with a kind of strangeness time and again. And the psychological recognition and emotions accumulated over years have emerged, too. Scenes filled with history and specific meanings are either diminishing quickly or existing in a super-realistic and isolated manner – separated from our life, or existing in real life without its original meaning. However, we still coexist with them, or even enjoy them.'[7]

Wang Chuan's work consists of neither a crisp photographic capture nor a virtual realization of an imagined past, but rather a series of blurred images with pixelated details, appearing like an unwanted trace of the mechanical process, resisting the artist's hand.

(opposite)

52. Wang Chuan, *Eight Great Sites of Beijing: Jintai Xizhao*, 2009

53. Wang Chuan, *Eight Great Sites of Beijing: Yuquan Baotu*, 2009

In actual fact, pixel is here the language. In our digital times, pixels – as a technically important tool of mass communication – allow an image to be easily compressed and transmitted; more or less the whole world can be recorded or re-interpreted through a pixel-comprised reality (the German photographer Thomas Ruff similarly discovered that everyday images downloaded from the internet at a low resolution could be developed to obtain a painterly or impressionistic quality when deliberately enlarged far beyond their photo-realist tolerance). Originally trained as an illustrator, Wang Chuan does not solely rely on digital technology to generate pixels automatically by compressing images; rather, he *paints* them. For this generation of digital-era artists, pixels are no longer just square-shaped, mechanical, cold replacements for the round grains of photographic film, revealing technological limits. Instead, they are seen as a new form of visual vocabulary with a particular aesthetic orientation to be appropriated, expressed and accumulated, like traditional brushstrokes on a semi-abstract canvas. Rather than using pixels to obscure original parts of his images, Wang Chuan intentionally highlights what is obscured. The traditional criteria of photographs become irrelevant here, while the visual quality of digital images cries out to be reassessed. What do we really see when we view this artist's printed work? A blurry photograph with hundreds of thousands of pixels? Or a precise depiction of contemporary China? In the Chinese social and cultural context, the language of pixels has been developed into a new conceptual proposition to reflect the distance between historical and contemporary existence, and the distance between the lives that one experiences from one day to the next. For example, one of the eight sites – Jintai Xizhao – originally designated by the emperor based on the aesthetic acknowledgement of its natural environment as a divine place for imperial tombs, has now developed into a Central Business District for the world's fastest developing city, known for the skyscrapers of SOHO, China World Trade Centre and the CCTV Headquarters. No trace can be found to prove its past life, except for a stone tablet left by Qianlong and the name of a subway station built on Line 10 for the 2008 Olympics.

In his 2011 work *Dragon*, Wang Chuan explored the appearance of the renowned Chinese *long* (a mystical creature, usually translated as 'dragon') in everyday life [54, 55]. In contemporary Chinese society, such images and artefacts – without their original cultural context – become insignificant visual tags, the symbolism of the creature somehow displaced. Similarly, Wang Chuan's series *Colourful* extends his discussion on the awkwardness of visual legacies situated amid on-going urban development [56, 57]. During a field trip, driving across the loess plateau on the national expressway for example, he noticed that the former natural landscape of northern Shanxi Province had been reshaped. Along the road, blocking views into the distance, there were crowded rows of stone carvings and tablets, including dragons, unicorns, lions and elephants, all commercially and roughly fabricated as false traditions, to be placed inside government buildings, courthouses and restaurants for urban decoration or to illustrate beliefs. At tourist sites, where fakes are even more legitimized, a traditional-style pagoda can swiftly be made with colourful fabrics as an attraction. The exception in Wang Chuan's series is the authentic memorial archway, probably built in Qing dynasty times, with a wall

54. Wang Chuan, *Dragon, No. 28*, 2009

55. Wang Chuan, *Dragon, No. 29*, 2009

56. Wang Chuan, *Colourful: Dreams Come True*, 2013

(opposite)

57. Wang Chuan, *Colourful: Longqing Valley Pagoda*, 2013

constructed to protect the relic. The characters on the archway have been pixelated, so the structure's significance remains unclear. However, the large slogan on the wall arbitrarily responds with an alternative proclamation. It reads: 'Let dreams rise from here.'

Wang Qingsong has stated, 'In Beijing, alongside new residential properties, shopping centres or office buildings launched for the market every day, and new roads laid out according to further urban plans, messages singing the praises of a new urban life are spread through the delightful words of advertisements. If you drive around Chang'an Avenue, the second or third ring road in central Beijing, all kinds of appealing things – Louis Vuitton, Park Avenue or Hong Kong Villa – enthusiastically catch your eyes through the gigantic advertisements' … but, as the artist goes on to reflect, 'Where is the soul of our city?'[8] In his 2004 work *Competition*, Wang Qingsong set up a huge backdrop, 14 metres high (46 ft), to mount more than 600 posters, a random selection of popular phrases and commercial slogans from advertisements, covering both domestic and international services, including real estate, luxury goods, general products, food, tourism and even foot massage, all hand-written by himself using a traditional Chinese brush or marker pens [58]. The atmosphere resembles that of a battlefield, with businesses competitively seeking the influence of their information and fighting for the next success in the market. Similarly, in his 2009 *Debacle*, Wang Qingsong collected all sorts of advertisements from billboards, product packaging, newspapers and magazines and reproduced them in handwriting on more than 3,000 sheets of paper, each 85 by 110 centimetres (33½ × 43¼ in.) [59]. These handmade posters eventually formed a monumental wall of advertisements, 12 metres high and 25 metres wide (39 × 82 ft), made of some 250 sheets of corrugated board. The wall was entirely covered with the posters, layer by layer, with some partially torn off, leaving others exposed underneath or patched on top, presenting a massive, semi-abstract image and revealing the relentless onslaught of advertising campaigns driven by economic forces.

Interestingly, both installations contain very few images. Written Chinese words predominate; indeed, the writings *are* the images. They are immediately reminiscent of the visual form of the Big-Character posters (*dazibao*) seen throughout Chinese political struggles, particularly during the years of Mao's Cultural Revolution. In a variety of lengths – one might consist of no more than a few sentences, another might be a massive treatise of 10,000 characters – the content of the posters was not only centred on propagating the directives of campaigns, but was also extended to criticism of factions and denunciation of individuals. At Tsinghua University, for example, 65,000 posters appeared on campus in June 1966, and in the propaganda sector of Shanghai some 88,000 Big-Character posters had appeared by mid-June. When these covered almost every available surface – a daily flood of slogans, directives, invectives and moral aphorisms for public life – the visual value of the text overpowered its literary content and constructed a 'landscape of writing'. If in the past, written posters were produced largely for political struggles and beliefs, today chaos ensues, as they also seek economic growth and a new vision of urban life.

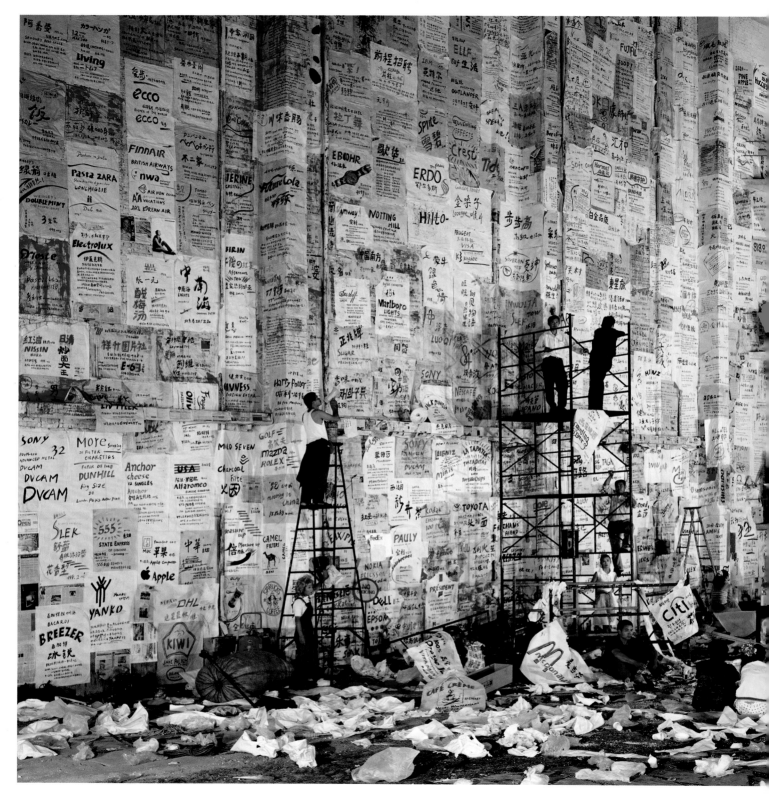

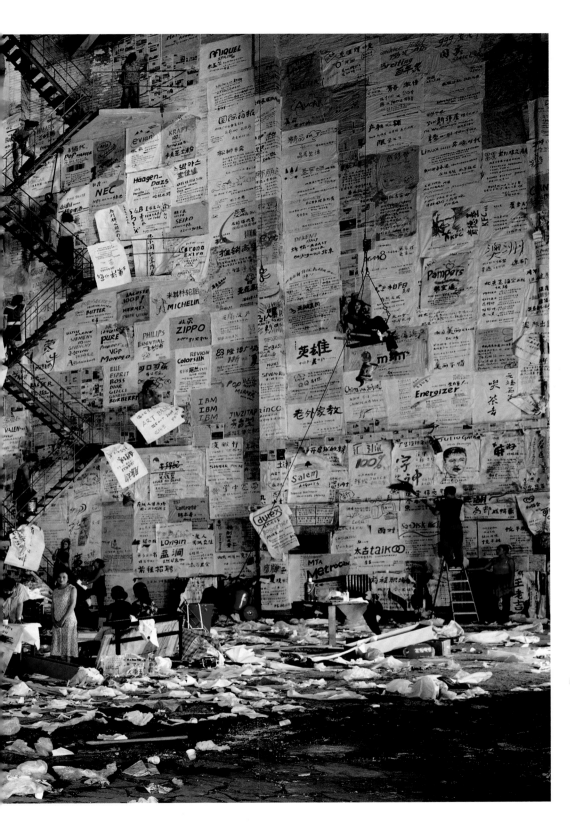

58. Wang Qingsong, *Competition*, 2004

59. Wang Qingsong, *Debacle*, 2009

Jiang Pengyi captured a series of night-time images of skyscrapers seen from quiet, narrow alley-ways located in residential areas [60, 61]. The sense of peace is broken by the luminescence being emitted by the skyscrapers. In contrast to the night cityscapes, the skyscrapers appear to be glowing with an intense brightness created by overexposure. The decision to imply overexposure is not to emphasize the thrill of the urban experience after dark, but to suggest a departure from reality – an illusion that is both alluring

(opposite)

60. Jiang Pengyi, *Luminant: Hanglun Plaza Shanghai*, 2006

61. Jiang Pengyi, *Luminant: Huaihai Plaza Shanghai*, 2006

and frightening at the same time. Whether standing alone or clustered in groups, these dazzling structures – which include shopping malls, hotels and office buildings, representing overdeveloped cities – cannot help but burn brightly and show off their splendours even throughout the night. Their luminosity seems to be out of control and increases avariciously in order to attract even more admiration, leading to strange urban spectacles for our growing pride and fear.

(opposite above)

62. Jiang Zhi, *Rainbow, No. 1*, 2005

(opposite below)

63. Jiang Zhi, *Rainbow, No. 2*, 2005

(above)

64. Jiang Zhi, *Rainbow* (installation), 2007

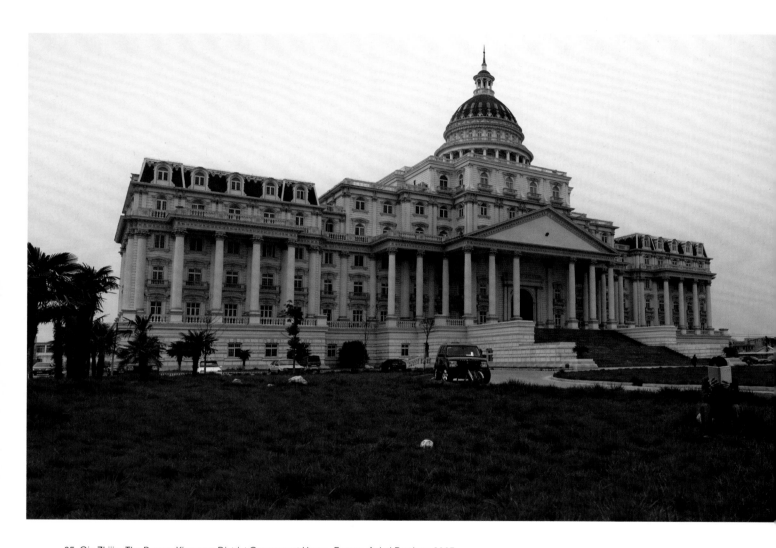

65. Qiu Zhijie, *The Dream: Yingquan District Government House, Fuyang, Anhui Province*, 2007

Jiang Zhi's (b. 1971) *Rainbow* is another spectacle. By using a poetic language, the artist depicts an urban reality dominated by consumer culture and commodity fetishism as an ironic fairy tale in which a splendid rainbow traces an arc across the sky [62, 63]. The rainbow in fact consists of hundreds of neon lights collected from all over the city, originating in all kinds of commercial signs, both Western and Chinese, ranging from fast food restaurants, household products and news media to theatres, shops, clubs and banks – almost every commodity that one would expect to see on a high street. A careful reading is invited to discern the details of the artificial rainbow. Neon lights belong to our cities and are visually attributed to the prosperity of urban life. Their strategic, seductive power blinks on top of buildings, stimulating and nourishing the city's desires. In Jiang Zhi's work, these interconnected lures propagate together rapidly to form a collective advertisement in the shape of a rainbow. The natural phenomenon – according to Genesis, the sign arrived to symbolize God's covenant with Noah and his descendants – has been replaced by a manmade spectacle formed from fragments of urban highlights: a fantasy of earthly possession.

In the 2007 video installation that was an extension of this work, a modest interior is seen, featuring old-fashioned radiators and a single bare lightbulb hanging from the ceiling. Central to the piece is the window facing out of the damp wall, with a hopeful view beyond its metal frame: a forest of skyscrapers illuminated by the rainbow of glinting neon lights [64]. It seems to be the vision of the owner of the space, or perhaps generally that of urban inhabitants. According to Jiang Zhi, 'It is constructed as a surrealistic prospect, representing commercial consumptions that take place every day on the way towards the future. When all cultural and spiritual values have disappeared or been lost through urban development, then the pursuit of the material becomes the sole impetus in contemporary life. The previous utopian ideology is transformed into consumeristic ecstasy and greed, which can still be romantic, as ever.'[9] Bearing its multicoloured icons, this rainbow is no longer an assurance of living beings being saved from another flood, but a celebratory firework commemorating economic success, or else a sequence of flares warning of the coming flood of urban desires.

Through his field research, the artist Qiu Zhijie (b. 1969) has captured a series of images, *The Dream*, featuring some of the most recognizable examples of world architecture – the White House of Washington, DC, for example, somewhat surprisingly relocated to the county of Fuyang in northwestern Anhui Province [65]. In practice, the image was not achieved by a single shot: rather, it consists of many individual photographs assembled together to maximize image resolution and thus invite close observation of every detail, right down to the title of the book that covers the reader's face. Some of the chosen buildings are not just smaller-scale versions of the originals; they serve a full purpose as prefecture-level government houses. As the series title indicates, on the one hand, for the maker and the local, their architectural appearance reflects the imagination, a dream of power; on the other hand, for the visitor, the scene represents a fantasy, through a disorientating journey. In other cases, the chosen buildings serve

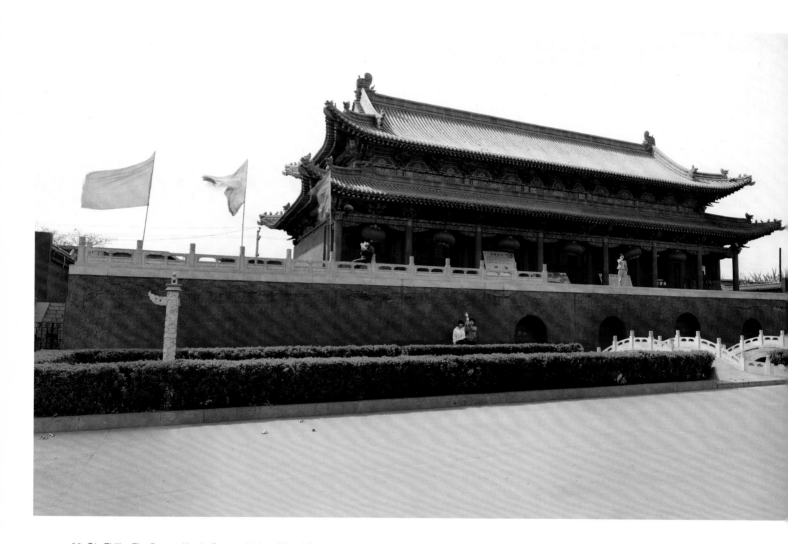

66. Qiu Zhijie, *The Dream: Yaodu Square, Linfen, Shanxi Province*, 2007

no practical function. These include copies of Tiananmen Tower, which once stood as the Gate of Heavenly Peace in the imperial city and hosted Mao's proclamation of the founding of the People's Republic of China in 1949. Many of these copies can be found outside Beijing, for example, in Linfen in southern Shanxi Province [66]. As before, they are usually miniaturized copies, as can be seen in the image opposite, with the proportions of the architecture and the people in front obviously being incorrect in comparison with the originals. These fake Tiananmens play a – possibly temporary – role as public sculpture, or as monument. They often act as photographic backdrops for local residents, similar to those popular scenes used in Chinese photo studios around the 1950s–'70s, such as the Nanjing Yangtze River Bridge and the Monument to the People's Heroes. Rather than being flat pictures, however, these are three-dimensional buildings, and, despite the quality of the construction, they are more realistic and more theatrical, creating strange new public spaces. They are not part of any theme park, such as the famous Splendid China (*Jinxiu zhonghua*) or its sister park, Window of the World, in Shenzhen, which contain collections of scaled-down national and international sites. Although the marketing plan behind the tourist attraction of Splendid China was 'to give more people of the world [a] better understanding of China, and thus promote … friendly [contact] between the peoples of China and other countries and give great impetus to the development of China's tourism',[10] visitors from China itself remain the main focus of attention. While 'Splendid China offers the clearest case of Chinese-style tourism philosophy in action, all delivered through the use of miniaturization',[11] domestic travels are still required to see all the tourist sites concentrated in one place. But these Tiananmen installations are located throughout the regions, and often right in the centre of towns: in other words, the sites travel to their viewers instead, and become part of their local life. To be photographed with the fake cannot prove that the subject has been on a genuine trip to Tiananmen, but it becomes a visual statement in and of itself, manifesting an important relationship. This is not simply a relationship between the photographed person and the authentic architectural entity in Beijing; it pertains to the historical and political significance of the relationship between subject and site. Any mock-up with even the smallest resemblance can provide easy access to this spiritual association, through a fetishization of the nationalistic symbol.

In 2007, a brand-new estate in Hangzhou was launched for the market. Designed around the original natural environment, it was built on Xiang Lake, a tourist-resort area of the province, to, as the advertisements said, 'provide multiple services for vacations, tourism, shopping and business meetings, and to shape an insular lifestyle and leisure spectacle of modern China'. The estate contains over ten theme parks or squares and up to thirty bridges of all shapes and sizes, each with individual names, somehow reflecting and reproducing the city of Venice in Italy. Zhang Peili's *City of Water Venice, Hangzhou* consists of two straight shots, taken from different angles and juxtaposed side by side, to document the principal public space which features an imitation St Mark's Square, complete with clock tower in the middle [67, 68]. From the photographs, the square is obviously not an exact replica of the original, and the proportions have been inaccurately

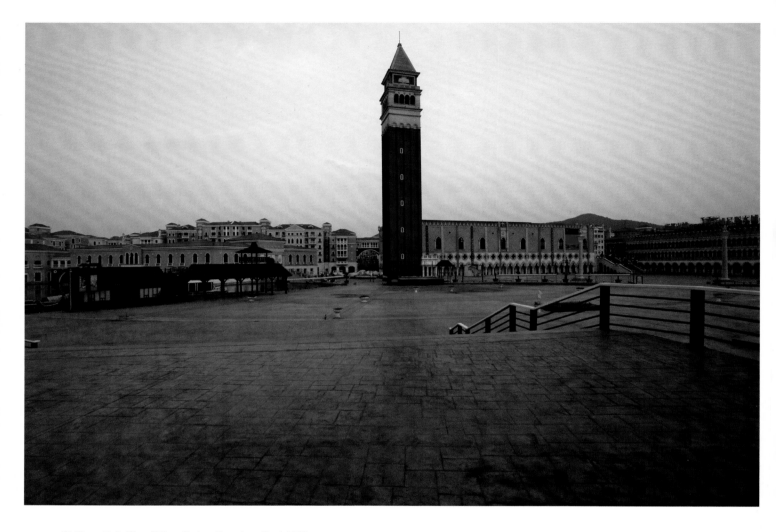

67. Zhang Peili, *City of Water Venice, Hangzhou, No. 1*, 2007

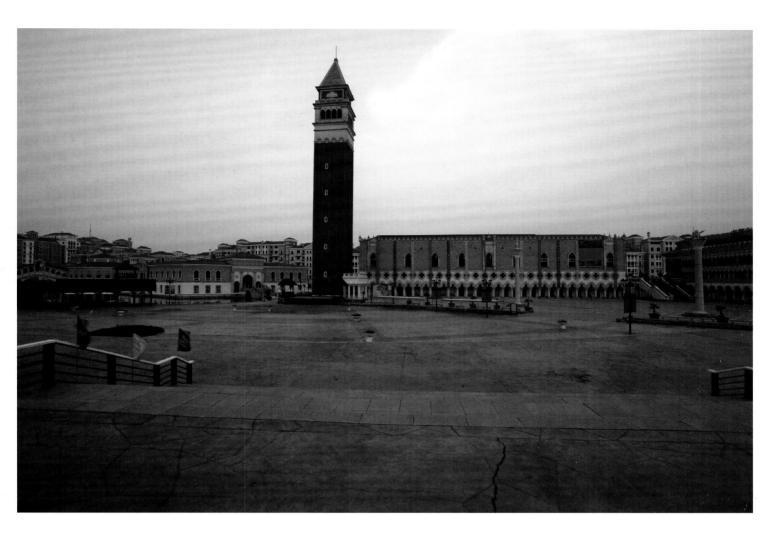

68. Zhang Peili, *City of Water Venice, Hangzhou, No. 2*, 2007

reproduced; it is also hard to read any architectural details to compare quality, for example, the façades with Romanesque marble carvings and decorations around the arches and doorways. What one can observe in the foreground of the second picture is a crack that has already appeared in this newly built and unused estate. Nevertheless, the square probably looks Venetian enough for the local people in China (just as Westerners appreciate what generally passes for Chinese food overseas). St Mark's Square, originally built over five hundred years ago and forming the social, religious and political centre of Venice, finally travels to Hangzhou, where a 'fetishization of the foreign' takes place.

Hu Jieming (b. 1957) provides us with a series of photographs in the form of postcards. In contemporary society, postcards have become a special medium for presenting sights – particularly historic or contemporary architectural landmarks, or urban skylines and environments – as glossy tourist images. These can make distant parts of the world visible and can bring exotic sights right in front of us. In comparison with an internet image, a decently printed postcard – always stage-managed to be more attractive than the actual scene – can somehow be even more convincing than a photograph. It looks beautiful and *true*. It must exist. In fact, a postcard photograph is not the real thing, or is only a visual fragment of the real thing. When it is sent through the post, it can be further transformed: not just visual evidence of an existing place, but evidence of a visit; proof of the bodily experience of having been. With his series *Somewhere*, Hu appropriates images from postcards around the globe and fabricates new scenes, featuring some of the world's most renowned tourist sites but working them so that they appear to be of unknown places. For example, a group of huge Western-style glass domes might replace the halls of the imperial palace dominating the Forbidden City [69]. Or Yu Garden's Nine Zigzag Bridge in Shanghai might lead visitors beyond the pavilions in the lake towards the skyscrapers of Chicago in the near distance [70]. In the centre of Tiananmen Square, instead of finding the Monument to the People's Heroes and Mao's Memorial Hall, there might appear a different set of mausoleums – the Sphinx and the pyramids – located on the central axis [71]. The image of the square must have been taken from the balcony of Tiananmen Tower, or as if formed by the dignified gaze of Chairman Mao looking out from his portrait on the Gate. The individual components on the site are all perfectly real, including the Golden River Bridge in front of the Gate, pedestrians, traders, tourists, cyclists and the late 1980s-style buses passing through Chang'an Avenue … until the eye reaches the Egyptian complex that is merged into the background.

Chi Peng (b. 1981) responds to the dramatic urban changes taking place in his country through the legendary character in Chinese classic literature, the Monkey King, who knows 72 polymorphic transformations to turn himself into various animals and objects, and is able to travel fast with a single somersault. The increasing powers and hubris of the Monkey culminate in his rebellion against Heaven, but eventually result in his downfall when Buddha decides to keep him trapped beneath Mount Five Elements (*Wuxing shan*) to learn humility. The punishment lasts for five hundred years until the Monkey is released to become a disciple of the monk Xuanzang on their pilgrimage to

69. Hu Jieming, *Somewhere: Palace*, 2004

94

(opposite)

70. Hu Jieming, *Somewhere: Shanghai–Chicago*, 2004

71. Hu Jieming, *Somewhere: Square*, 2004

the West, during which he proves his courage, wit and supernatural powers by defeating many monsters. In Chi Peng's work, the hitherto invincible hero encounters a demonized contemporary urban landscape. Even with his magic golden staff, he becomes impotent, entangled in a trio of skyscrapers that rise in a giant braided peak up into the layers of heavenly clouds [72]. Although a pair of pheasant feathers, traditionally the 'soul' of the Monkey King's costume, waves valiantly in the air, it is inevitable that he will be detained once again – this time by the powerful forces of urbanism, possibly for another five hundred years, with no way to break free.

As reflected in another piece, *Sprinting Forward*, Chi Peng might himself have decided to escape from urban reality [73]. In a dreamlike scene set in Wangjing, a district of Beijing, a red bus can be seen, together with a group of naked young men (or one man multiplied) and a formation of red planes – all moving at high speed, perhaps desperately breaking away from rapid urban development and speeding towards an unknown destination. The scene portends alarm at imminent disaster, but the atmosphere is not overtly fearful; in the end, one might even perceive a sort of carnivalesque parade, joining in all the urban excitement.

By contrast, Chi Peng's work *I'm a Little Scared, The Sky is Getting Gloomy*, captured in 2008 from the top of Jin Mao Tower in the Pudong district of Shanghai, shows a different scenario. Emerging from the Bund area at the west bank of the Huangpu River, the cityscape is completely covered in a smog-like nebula, though numerous skyscrapers (without any digital rendering used) appear spectacular even in the haze [74]. From this panorama, the city where a person lives every day can become unfamiliar, and from the perspective of such a grand view the day-to-day experience might seem difficult to recognize and locate. In addition, the heavy mist, which the artist did not intend to prefigure the recent pollution in China, further evokes a feeling of insecurity; a feeling of being led towards an indistinct future. Notably one can observe that in the artwork there are many discreetly hidden shadows in human form (the artist himself), standing upright in either the near or far distance. In Chi Peng's imaginary world, it remains unclear whether these gigantic figures, as an illusion, are coming into the city or moving away from it: their silhouettes are placed at the edges of the urban conurbation or right on the boundaries between earth and sky; known and unknown.

(opposite)

72. Chi Peng, *Mount Five Elements*, 2007

73. Chi Peng, *Sprinting Forward, No. 2*, 2004

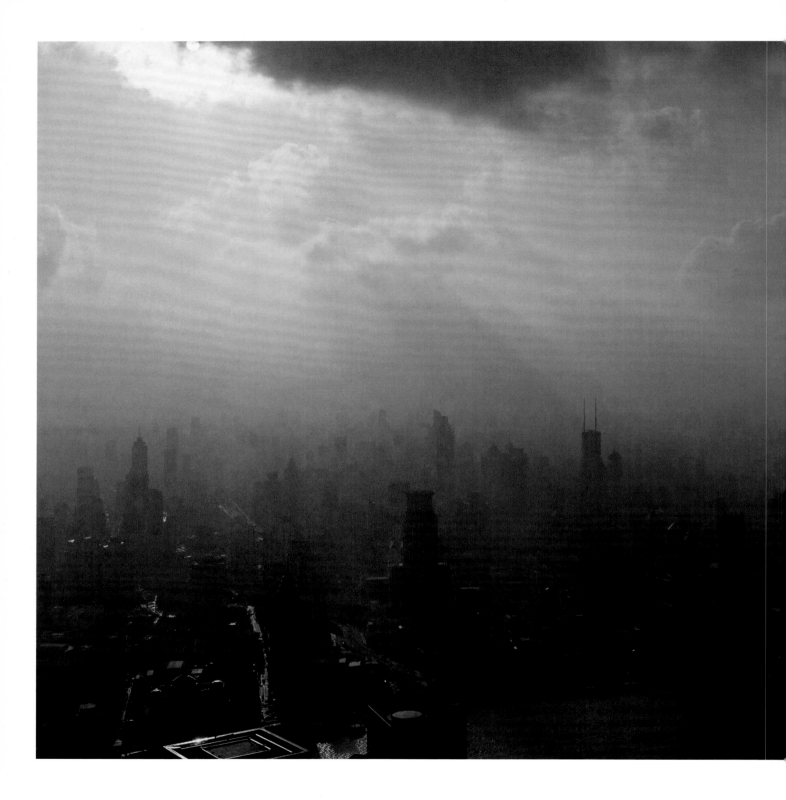

74. Chi Peng, *I'm a Little Scared, The Sky is Getting Gloomy*, 2008

Again set in Shanghai, Yang Zhenzhong's (b. 1968) 2002 work, *Light as Fuck* (*Qing'er yiju*), depicts the ease with which a single finger holds up the feather-light landscape of the representative urban construction of Lujiazui, originally a slum area but subsequently the new financial centre of the city and China's most condensed district of skyscrapers developed since the early 1990s [75]. The Oriental Pearl Tower, built as a distinct landmark in the Pudong area, leads the glamorous skyline in forming the new identity of Shanghai, symbolizing its economic achievements associated with complete self-confidence. However, as the artist reflects, 'With the disappearance of old buildings and the springing up of new ones, suddenly we come to realize that the city of the past has been changed beyond our recognition. When the sights in a city no longer bear historical significance, its images in my view will become more and more misty and "light". Such cities, like Shanghai, make people feel excited and depressed at the same time.'[12] At the artist's fingertips, the entire iconic city is turned upside down. As revealed in the video version of the work, it is more than 'light'; it basically has no weight at all, though it requires the particular skill of a performer to balance the horizon in case it falls. The work does not show how the cityscape could possibly be put back down. As the exercise of balancing is carried out, so the disturbing unpredictability of the situation, as well as the temporality and uncertainty behind urban prosperity, is divulged through a sense of humour. In Yang Zhenzhong's interpretation, the economic revival of the city, and the ambitions of China's urbanization in general, become part of a circus act in which the performance can never stop so that the charade can continue. By using a playful image, any criticism seems to be far from bitter or heavy; indeed, it seems to be 'light as fuck'. But in fact the image can be read as utterly subversive of the government's promise of social stability and economic success. China's new vision for urban development – 'better city, better life', as the slogan for Shanghai's 2010 World Expo went – is, literally, in hand.

75. Yang Zhenzhong, *Fuck as Light*, 2002

3.
An Alienated Home

A focus on the once familiar, now strange or endangered

What is an image of a hometown? Popular pictures of the Lujiazui skyline in Pudong, for example, might depict Shanghai as one of the most vibrant cities in the world, but they do not show it as a hometown. While the Central Business District of Pudong has become a political, economic and touristic landmark for outsiders, for insiders – the Shanghainese who find themselves culturally associated with the city – it can neither validate their personal memories of their daily lives, nor can it offer any intimate perceptions of home. A hometown is an urban space of relationships – for people to inhabit, work in and love. But, in China today, such spaces never continue to look the same. Even to those who have never been away for long – those who are living through and experiencing the rapid urbanization – it can be difficult to recognize some of the once most familiar places in their home cities from one day to the next. Home has become alien, or worse.

Chaiqian – demolishing (residential buildings) and moving (residences) – appears to have become a popular word over the last few decades in China. Acts of *chaiqian* are initiated primarily based on governmental strategy, with or without consultation, and in many cases they can be executed forcibly. In cities, traditional residential buildings have little chance of surviving, including the courtyard houses (*siheyuan*) and alley-ways (*hutong*) of Beijing, the historical types of residence sometimes referred to as Chinese quadrangles, and the 'stone gate' (*shikumen*) homes of Shanghai, a style of residential architecture from the semi-colonial period. In particular, such places situated in cities have largely been replaced by commercial centres, while the residents are relocated to newly built high-rise apartment complexes on the urban outskirts. Although the plan is intended to provide modern amenities, inevitably, because of the substantial urban changes, social relationships and perceptions of home in China's urban life become vulnerable.

Wang Jinsong's (b. 1963) *One Hundred Chai (Baichai tu)*,[1] completed in 1999, stands witness to the reconstruction of the city of Beijing [76]. From the 1990s, the Chinese character *chai* (to demolish) began to appear all over the capital, either in bold white or spiky red. Marked on outer walls, or on doors and windows of the numerous residential buildings to be removed, this character became the bulldozers' target when low-rises had to make way for the grandeur of height. Wang Jinsong spent over a month searching the city for the character in various forms, so that he could photograph it to mark the final scenes of disappearing homes. The way the *chai* is handwritten seems 'despotic, truculent and even tyrannical in many cases,' says the artist. 'The impact is not from the literal meaning of the character, but from the visual format and execution of the writing.'[2] As discussed earlier (see p. 77), written Chinese words can be seen as a kind of image, and in Chinese culture the art of calligraphy is sacred. In public spaces, inscriptions appear centrally over city gates and arches; on beams or pillars of historic buildings;

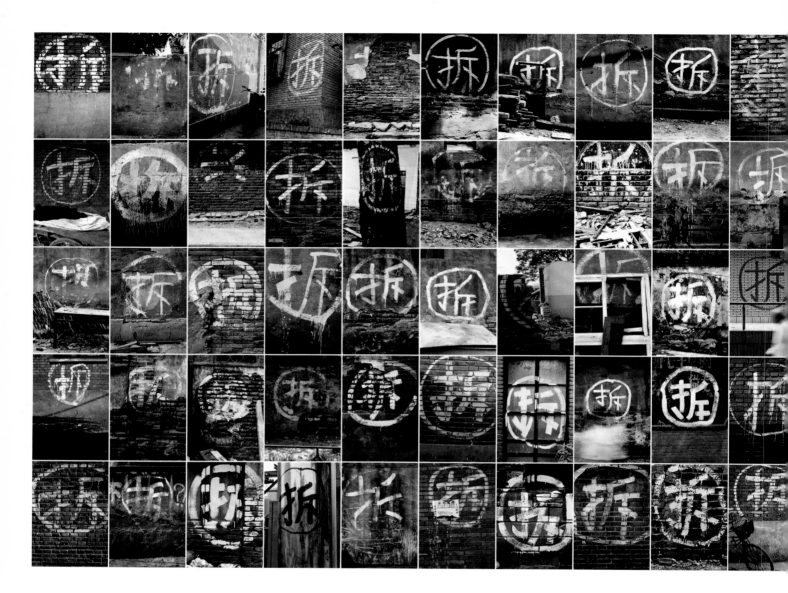

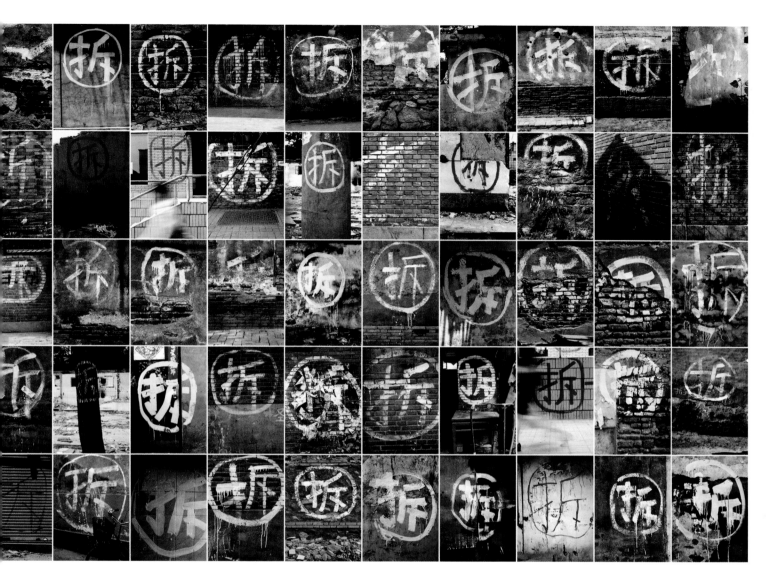

76. Wang Jinsong, *One Hundred Chai*, 1999

carved on wood or stone as commemorative introductions, poetic expressions or political endorsements. However, the people who made the marks of *chai* are not intellectually trained calligraphers and their writings demonstrate no traditional aesthetics, but instead a kind of arrogance of authority. Each of the characters is usually highlighted aggressively with a determined circle, as if its author has assumed the visual power to sentence a construction to death, and at the same time to deprive people of their home.

When the artist Inri joined Rong Rong from Tokyo in 2000, their first home was a traditional courtyard house in Liulitun, a residential area on the east side of Beijing. They got married while there and went through the most difficult time of their artistic lives, surviving on very little income. However, to the couple, 'Liulitun is almost like a *shiwai taoyuan*' (literally, 'a land of peach blossoms beyond the world': an earthly paradise, the concept first invented by Tao Yuanming [365–427] at the time of the Eastern Jin dynasty). 'Although it was only for a short period of time, we enjoyed Liulitun. Up until today, it is always alluring and dreamlike in our memories.' Soon this place, too, faced its destiny of being demolished. After a three-month residency in Australia in 2001, the couple returned to find their land of peach blossoms collapsed. 'In the taxi, all the way from Beijing airport back home,' they recall, 'the landscape was crumbling away, with many houses and streets disappearing, as if they had experienced an air raid. The minute we saw this had happened to our own home, our hearts sank and we collapsed, too.'[3] Like other inhabitants, Rong Rong and Inri were forced to move. The couple lost their first home, together with all the associations they had cherished that had solely belonged to that house. Rong Rong decided to make an artwork by revisiting the area before everything vanished during redevelopment. *Liulitun* is a series of images taken while the houses were in the process of being destroyed. Juxtaposed against broken windows and collapsed walls, the couple always appear, both dressed in black. The involvement of the figures was carefully managed so that they were detached from a simple documentary of the demolition, instead presenting a documentary of *witnessing* the demolition. Without any possibility of resisting the brutal invasion of private space, the pair perch on top of a courtyard gate [77] or sit amid the rubble with an enormous bunch of white lilies [78], grieving over the loss of place and, more importantly, their personal relationship to their home. In another image of explicit helplessness, the couple hold onto one another in a demolished, roofless interior that takes the shape of a large boat, as if fearlessly sailing on a sea of ruins, or more likely run aground at this moment of disaster. The future destination of the journey remains unknown.

(above)

77. Rong Rong, *Liulitun, No. 3*, 2003

78. Rong Rong, *Liulitun, No. 8*, 2003

79. Zhang Dali, *Dialogue, No. 95a*, 1995

Construction sites can be found everywhere in China: buildings masked by scaffolding, and the streets suffused with energy and confusion. Returning to Beijing after a six-year stay in Bologna, Zhang Dali (b. 1963) found a strange new reality. In his words: 'This is the city I feel so familiar with, yet at the same time it's unrecognizable.' With the power of urban development in mind, Zhang Dali believed that art would only be meaningful if it went outside of the artist's studio and back to reality. In 1995, he decided to pursue the graffiti practice he had first begun in Italy, seeing the whole city as his studio [79]. 'I used graffiti as my weapon, to connive with the oppression in my soul,' he has said. 'I took the photos as artworks, or as a visual archive which records the process of the city being dismembered and the new life born through the ruins. Changes are taking shape under a sky full of dust and within a forest of reinforced concrete. Some people keep telling me that the future will be much better. I don't know how good it will be, but I do know for sure that life is changing, and I feel the urge to document the changes and to express myself.'[4] Zhang Dali's graffiti was duplicated and gradually spread across the city. On walls, bridges and other public spaces, a spray-painted silhouette of a large bald head, alone or in groups, became a familiar image to many residents of Beijing. The profile quite clearly came from the artist's own identity. Thousands were produced in free-hand, mostly on construction sites, to form part of the urban landscape or, as the title indicates, to initiate a 'dialogue' with the city and its transformation. For example, it was scrawled on a half-demolished building in a Shanghai residential area, above an advertisement for a removal company and with the vast Jin Mao Tower rising behind the wasteland [80]. The sudden appearance of the artist visually disturbs the development, negotiates between the old and new landscapes, and witnesses all the acts of destruction and construction.

In the series *Demolition*, an extension to the graffiti work, Zhang Dali chiselled out his painted heads with the assistance of some hired construction workers. The resulting holes provide a glimpse in the distance of either a surviving cultural legacy, such as a corner of the Forbidden City covered with gold tiles [81], or a modern building in the process of construction, such as Beijing's World Financial Centre [82]. Zhang Dali's graffiti was one of the simplest forms of public art, or mass art, and yet he turned it into a performance, presented through photographs. As art historian Wu Hung has said: 'On the one hand, they record site-specific art projects that have been carried out by the artist. On the other, these projects were designed largely to be photographed, resulting in two-dimensional images as independent works of art. Consequently, the role of Zhang Dali's graffiti self-portraits also changed: no longer stimulating interactions on the street, it became a pictorial sign that heightened an urban visual drama.'[5] In fact, when the head shape was carved into the wall, the graffiti became sculptural and architectural. It was no longer merely a visual testimony to the performance; it now became an artistic action determinedly applied to the architectural ruins to commit the artist himself as part of the destroyed homes. Work on the *Demolition* and *Dialogue* series lasted for more than ten years, as evidenced by the last piece, made at the end of 2006 [83].

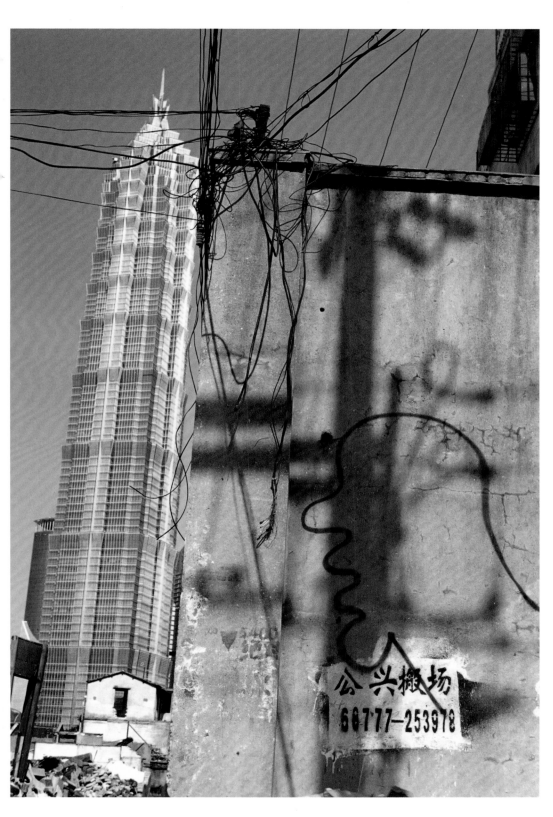

80. Zhang Dali, *Dialogue, No. 101a*, 2000

(opposite)

81. Zhang Dali, *Demolition, No. 125a*, 1998

82. Zhang Dali, *Demolition, No. 123*, 1998

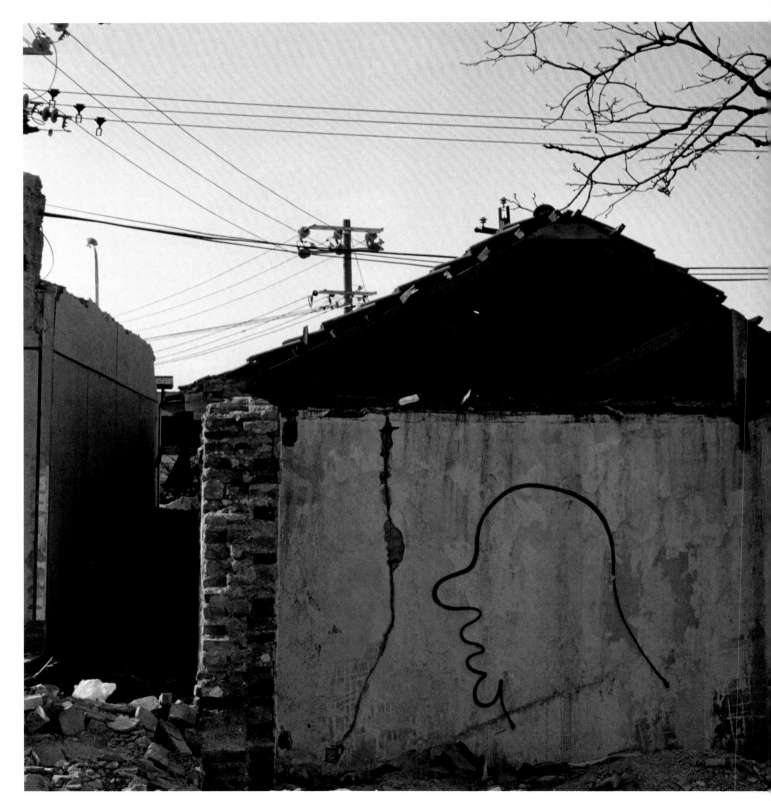

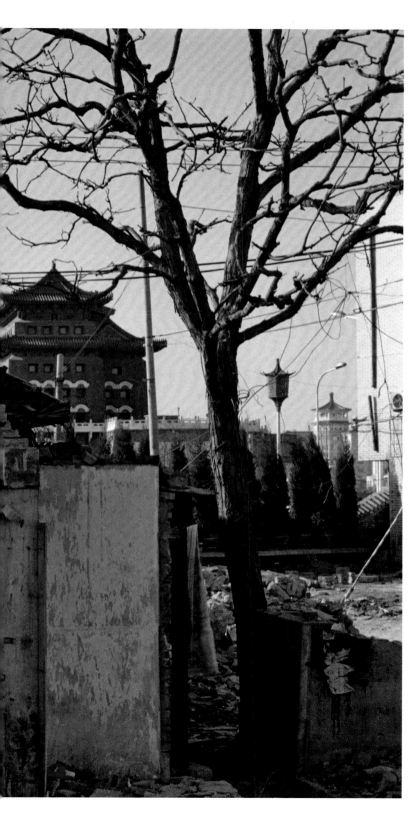

83. Zhang Dali, *Dialogue, No. 1210a*, 2006

The execution of *chaiqian*, however, does not always go smoothly. In some cases, so-called 'nail households' (*dingzi hu*) refuse to move or to have their homes relocated. Such non-cooperation – normally imputed to the failure of negotiations for compensation – can result in forced relocation by the authorities, to, as developers say, 'unblock' the development of a city. In 2007, in the Yangjiaping neighbourhood of Chongqing, an ordinary two-storey residential house – probably in need of some immediate repairs – became extraordinary. Via news reports and Chinese social media, it became labelled 'the most stubborn nail household' in the history of China's urbanization. After many months' resistance, the house appeared to stand more than 20 metres high (66 ft), since its foundations had been completely exposed. It now stood in a huge excavated pit approximately 10,000 square metres in area (108,000 ft²) and 17 metres deep (56 ft), and was absolutely cut off, with no supplies of water, electricity or gas and no safe method of access.

At the end of March 2007, Jiang Zhi made a special trip to the site and set up a theatrical spotlight on full beam from the top of a nearby high-rise. In the final photograph, the 'nail household' appears dramatically lit by night, a last tenacious fort besieged by invisible enemies in the darkness [84]. The banner on the building, possibly hung by the owner, reads: 'The state respects and ensures human rights.' Since the owner is not visible, the reshaped house with its naked root makes itself the protesting hero, standing alone fearlessly, to defend the remaining patch of 'home': a temporary monument to the excitements and frustrations of urban development. In the end, just like millions of other home owners, this one, too, was unable to halt the pace of the new urban revolution. What the artist captured was like a magic show: the miracle of the 'most stubborn nail household' is unveiled as the centre of attention, but we all know that it can disappear at any minute once the spotlight goes off. On 2 April, just a week after the photograph was taken, the house was removed overnight.

In light of the endless urban constructions, the Beijing-based artist Yao Lu (b. 1967) sees his hometown differently. At first glance, he seems to belong to the traditional *literati* group, and his *New Landscapes* merely present a series of *shanshui* (literally, 'mountains and waters') in the *literati* style of landscape painting, with the same reclusive proposition and poetic mood [85–87]. Only upon closer observation can it be detected that the landscapes are in fact ruins composed of mounds of rubbish covered with green or black dustproof netting, as found on construction sites in every big city in China today. The scenes are composed digitally and transformed into *literati* landscapes by the addition of rivers, clouds, trees and pavilions. The current social and environmental transitions do not necessarily bring excitement to Yao Lu; on the contrary, they seem to invoke a feeling of loss. As he has said, '[The present] becomes a reality filled with endless opportunities for constructions and changes, yet, at the same time, catastrophic destructions and reconstructions. No one cares about this reality, nor is there any power that could possibly slow down the pace of its development. Envisaging the disappearing, at the centre of my work lies a sense of melancholy and nostalgia, quite helplessly.'⁶ Through the artist's digital manipulations, the dustproof netting not only conceals the

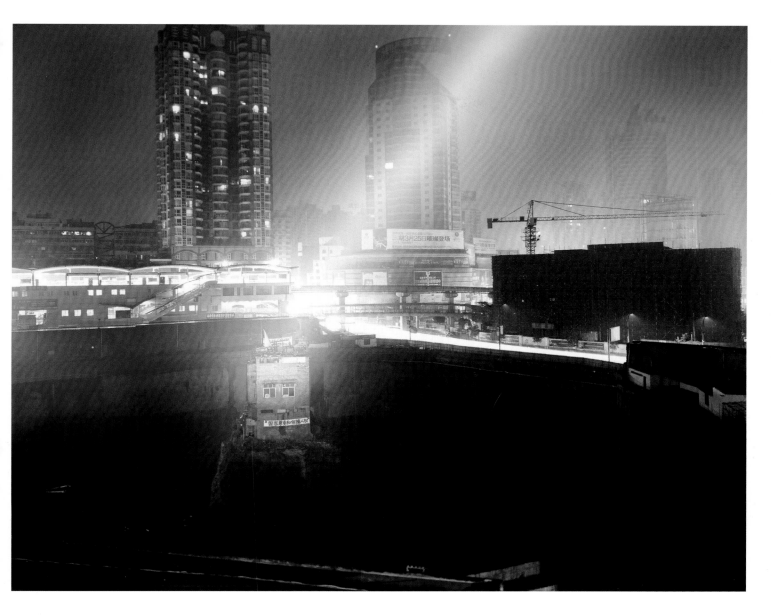

84. Jiang Zhi, *Things Would Turn Nails Once They Happened*, 2007

85. Yao Lu, *Green Cliff with Floating Clouds*, 2008

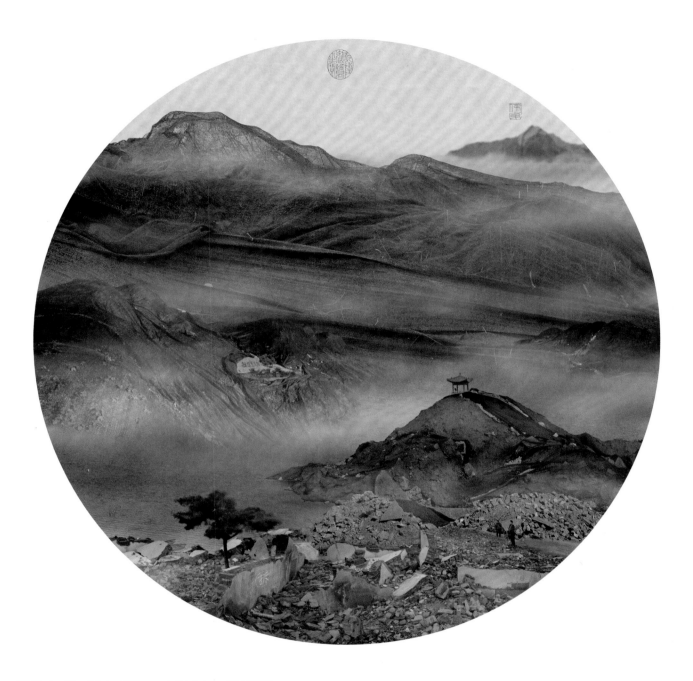

86. Yao Lu, *Mountains and Streams in the Autumn Mist*, 2008

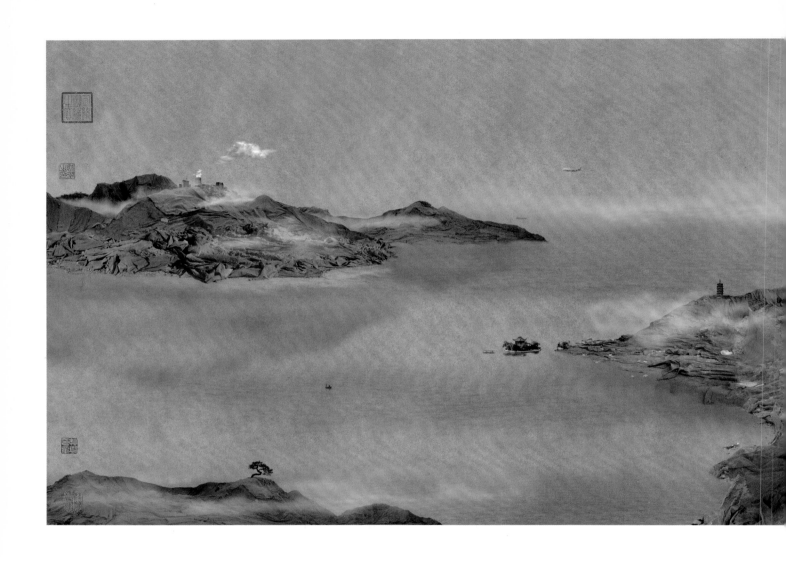

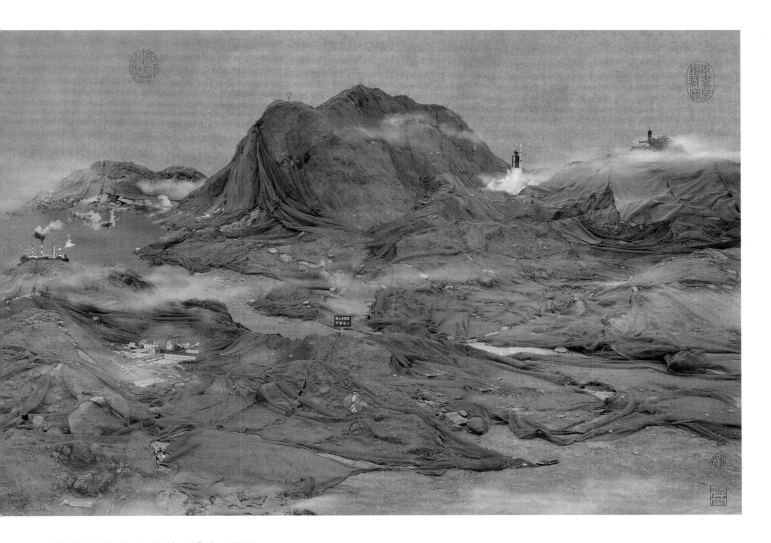

87. Yao Lu, *Dwelling in the Mount Fuchun*, 2008

ugliness of daily life, but also shapes a new symbol of contemporary urban China. No longer disordered remains left on working construction sites that constitute a disturbing environment, the mounds of waste have been transformed into traditional aesthetic forms. Although working with some of the most advanced cameras and forms of digital technology, Yao Lu – as a 'contemporary *literati*' – apparently attempts to fabricate a 'reclusive' image; a spiritually peaceful world beyond secular life. His works offer a vision of humanistic scenes representing the *literati* mood and poeticism in a way that turns out to be engagingly humorous. But the aestheticism can only be tasted as a sugar-coated pill. The capsule encloses the bitterness of the artist's sense of loss, as well as his criticism of the cultural memory that has been collapsing alongside the urban structures of present-day China.

From a more positive perspective, brand-new homes in the form of apartments in tower blocks have been springing up throughout expanding urban areas. With extraordinary speed, over just a few decades, China has been reshaping the skylines of its major cities as it develops thousands of high-rises for the millions of people being relocated and migrating from the countryside. According to a recent report in *Foreign Policy* magazine, 'Chinese officials hope to link Guangzhou, already home to nearly 12 million people, and its sister cities in the Pearl River Delta, to create a "mega-city" of 42 million inhabitants spread across 16,000 square miles.' Chongqing, a municipality with 30 million people, 'constructs 700,000 units of public housing annually, with 430 million square feet [40 million m^2] due to be completed within the next three years alone'; and 'although Shanghai had no skyscrapers in 1980, it now [in 2012] has at least 4,000 – more than twice as many as New York'.[7]

Post-1980s residential high-rises all look fairly similar, with little individuality in style. Such public housing has, since 2000, been the main focus in Xiang Liqing's (b. 1973) work. This unadorned form of architecture, with its obvious functionality, has become the economic model for residential building throughout China. Referred to as 'the most dependable visual product produced by the Socialist planned economy',[8] this housing represents the majority social strata of China. In Xiang Liqing's series *Never Shaken*, his housing blocks look simple and modest, representative of most of the newly built homes for low- and middle-income households [88, 89]. The buildings are concentrated and reinforced, unit by unit, window by window, accumulating collectively to form a 'mega-tower'; a high-density home for many. The indistinct edges of Xiang Liqing's artworks indicate that they may be just a detail of a much larger whole, or a constantly increasing whole. Although the apartments are closely connected to one another, the images do not convey any sense of an intimate neighbourhood or the warmth of home; instead, they hint at a rather unpleasant environment (possibly even at overcrowded jails). Households have no choice but to conform and accept this new generation of 'collective space' – following on from the traditional courtyard lodgings and, later, the Socialist People's Commune – as a contemporary 'residential spectacle' in China.

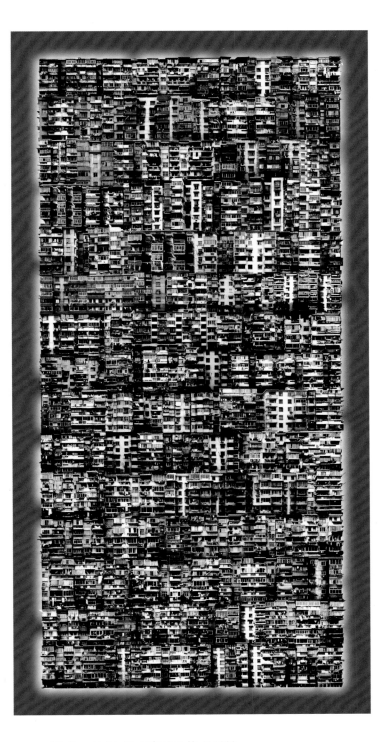

88. Xiang Liqing, *Never Shaken, No. 3*, 2002

89. Xiang Liqing, *Never Shaken, No. 5*, 2002

123

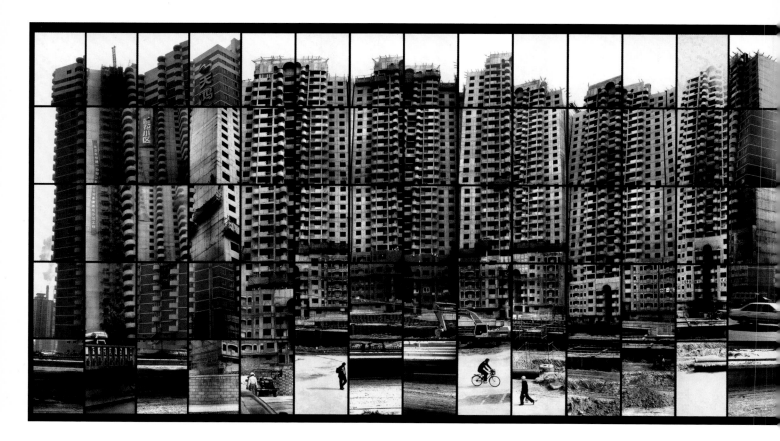

Unlike Xiang Liqing, who uses digital technology to emphasize the collectivity of residential spaces, Luo Yongjin (b. 1960) represents them through a series of traditional photographic collages. For example, he divided an entire complex of buildings – the Lotus estate (*Lianhua xiaoqu*) in Beijing – horizontally and vertically into a large number of sections so that he could photograph each one individually, thus obtaining a sufficient level of detail [90]. After disassembling his architectural entities, Luo Yongjin then reconnected them in a single mosaic image. He started to photograph the buildings when they had been roughly completed, but still had their scaffolding. Over a period of two years he then visited them regularly in order to rephotograph all the sections, recording the sequence of changes apparent once windows had been installed, exterior walls and balconies decorated, and front roads finished. The project became a visual diary, resulting in thousands of photographs that witnessed every changing part of the site and every stage of construction progress. More precisely, they witnessed a *transformation*, from bare architectural structures to finished residential high-rises; from geometric abstraction of cold materials to meaningful complex of homes. Any individual photograph is only a faithful detail of the spectacle, shot from a slightly different perspective each time: it does not represent the whole image on its own. The individual photographs reflect the fragmentary and temporal gaze of the artist. Once the images are assembled, the buildings therefore seem to be reconstructed according to a new scale of time and space, redefined by the photographic interpretation. In Beijing alone, there must be thousands

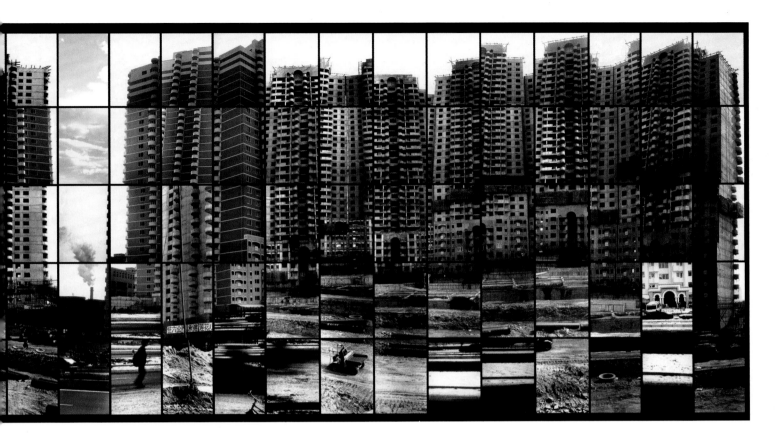

90. Luo Yongjin, *Chinese Cityscape: Lotus Block Beijing*, 1998–2002

of estates of this kind, and more will be built to meet the rapid growth of residential needs. Luo Yongjin has suggested a new photographic form better to respond to architectural configurations and their changing appearance in China. Taking a closer look at the collage, however, it actually resembles an incomplete jigsaw, in which many incorrect pieces still need to be replaced. Perhaps the jigsaw can never be completed. It can be seen as a metaphor for the on-going, seemingly endless urban development in contemporary society, full of avarice and arrogance, with all the deformed elements aimed at quickly projecting a magnificent future.

Shanghai is the hometown of Ma Liang (b. 1972), but to him it appears bigger, taller and somehow stranger every day. Following on from the Jin Mao Tower and the Shanghai World Financial Centre, both erected in Lujiazui, Pudong, the Shanghai Tower is the next super-skyscraper. With its 121 storeys standing approximately 632 metres high (2,075 ft), it is the tallest building in China, and the second tallest in the world. It surely manifests the success of urban development, the whole environment transforming to take on a scale that seems paradoxically to go beyond the limits of human control. As the artist has said, '[The city] keeps growing and metamorphosing every day, greedily, frantically and non-stop. It seems to be a queen ant with no eyes: a gigantic machine just for procreation, consistently and apathetically. Every individual inhabitant living within it is just like an ant. It gives them merely birth and life, but not love.'[9] In Ma Liang's series *Shanghai Orphan*, the modernized city is recognizable, the Oriental Pearl Tower shooting out from the skyline. The series appropriates the imagery of Edvard Munch's iconic work *The Scream*, with figures, grouped in twos or threes, all wearing the same masks impersonating an agonised expression against a tumultuous cityscape backdrop [91, 92]. The figures are unidentified, but, judging by the exposed hands and the ring on the finger, they are probably male and, in fact, the same person. He is desperate, running away from some external attack or source of terror. The scene is all the more horrific if the terror is essentially generated by his own hometown. He has nowhere to escape, or he becomes homeless like an orphan.

When, in 1993, Wang Qingsong left Jingzhou, a small town of 100,000 residents in Hubei Province, to realize his artistic ambitions in the capital, Beijing, he was initially shocked by the scale of the city, its population nearly two hundred times larger than that of his hometown. He witnessed firsthand all the dramatic changes that were taking place and experienced personally the situation of tens of thousands of migrants crowding into Beijing to pursue a new life. Since the late 1980s, there has been concern about the 'flood of migrants' (*mingong chao*) causing trouble in cities. The term 'blind migrant' (*mangliu*) is used as a label for unemployed people coming from rural areas. The term is an inversion of *liumang*, a pejorative expression equivalent to 'hooligan'. The inverted term consists of two characters: the first, *mang*, means 'blind' and the second, *liu*, means 'flow' or 'float', as opposed to anything rooted, fixed or stable.[10] Just as the term *liumang* acquired the meaning of 'hooligan', so its inversion, *mangliu*, is indirectly loaded with

(above)

91. Ma Liang, *Shanghai Orphan, No. 1*, 2011

92. Ma Liang, *Shanghai Orphan, No. 4*, 2011

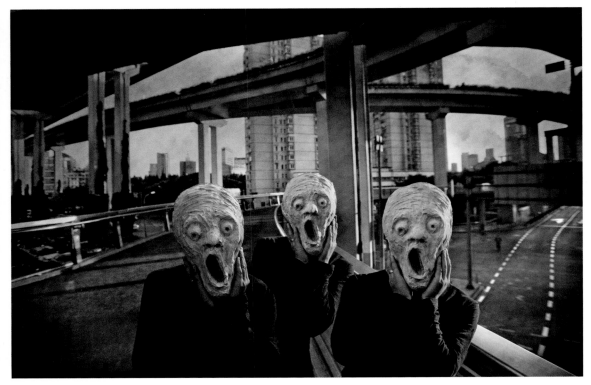

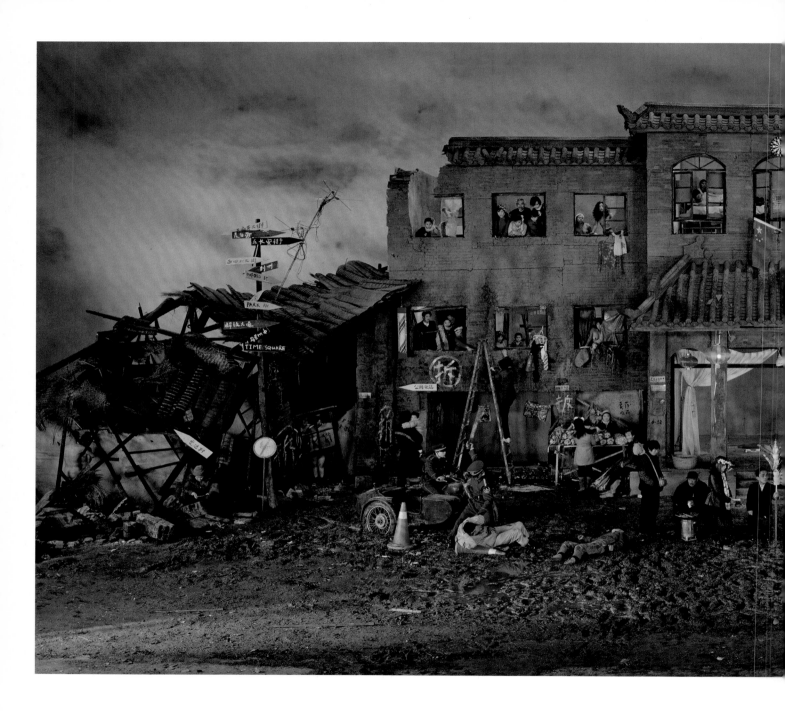

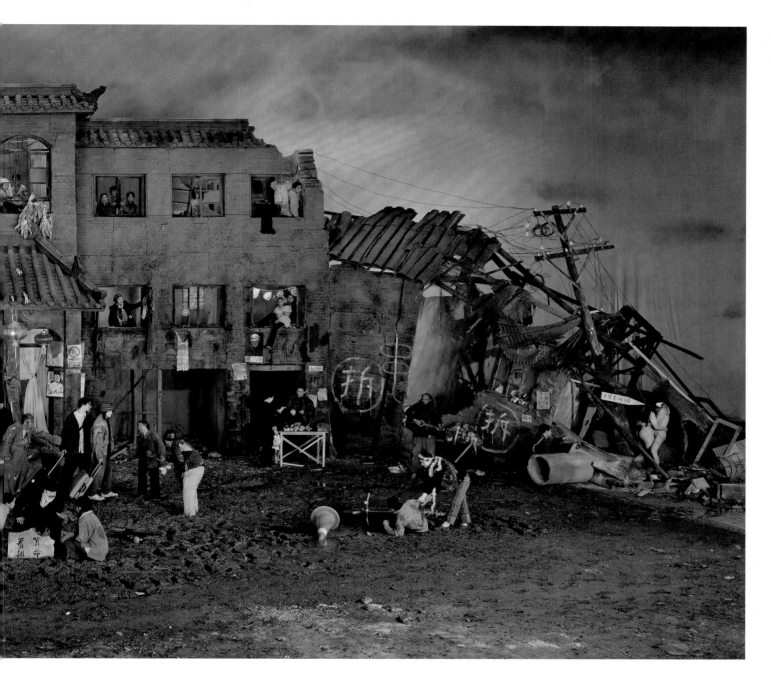

93. Wang Qingsong, *Dream of Migrants*, 2005

symbolic associations and implies the potential of social instability. As Wang Qingsong observes, 'This population is used to migrating from one city to another, travelling helplessly with little money and disreputable status. They can be recognized as a vibrant force [for urban development], but are largely regarded as signs of social disorder.'[11] In 2005, the artist set up a dramatic installation featuring the façade of a three-storey house in order to reinterpret the stories of the population of *mangliu* [93]. Men and women – elderly and young, dressed unusually or naked and undignified (which does not seem to be a concern) – are juxtaposed together against the architectural backdrop to present a theatrical scene. This is not designed to identify any particular period of time in history, but to capture a chaotic moment in the movement toward an uncertain future, indicated by the fortune-teller located at the centre of the stage. The 'set' is not necessarily intended to be realistic; it can be appreciated as scenographic, performative and unreal. Each window is a frame picturing a family of migrants. They are all carefully calculated as part of the image to be viewed, and at the same time they are part of the audience, watching the happenings around us all. No privacy is required. Their collective home, partially ruined, is temporary. It does not necessarily need any repairs; it might just get ready to 'float' with them to their next destination.

As mentioned earlier (see p. 56), Jiang Pengyi similarly spent his childhood in Ruanjiang in Hunan Province before moving to Beijing with his family. He writes, 'In my hometown, there was just one street, which would only take ten minutes to walk from one end to the other. It was my whole world, undisturbed and steadfast, with almost no change over the years. I was used to the fact that everything remained the same, and my life was very peaceful day after day. When I first left home to go to my senior high school in Beijing, I was thrilled by the scale of the city and its dynamic movement. But as soon as I realized that I was just one tiny individual from a small place, my excitement vanished. I felt unsafe and ashamed in such a vast urban environment.'[12] A sense of alienation undermined the artist's enthusiasm to see Beijing as his new home, until one day he had a sublime experience on Fragrant Hill (*Xiangshan*), about 18 miles northwest of Beijing. From the top of its Incense Burner Peak (*Xianglu feng*), he could see the entire city spread out at the foot of the mountain, the everyday lives of some 20 million people unfolding below. Jiang Pengyi's desire to take control of where he lived is reflected in his 2008 photographic series, *Unregistered City*. Gigantic skyscrapers are reduced to miniatures through use of the bird's eye view and relocated to dilapidated interiors [94–96]. Sometimes – within piles of dust and everyday waste such as abandoned books, beer bottles and a cattail leaf fan, under the glow of a setting sun, or in a discarded bath tub like a harbour environment – the bustling cities can easily be

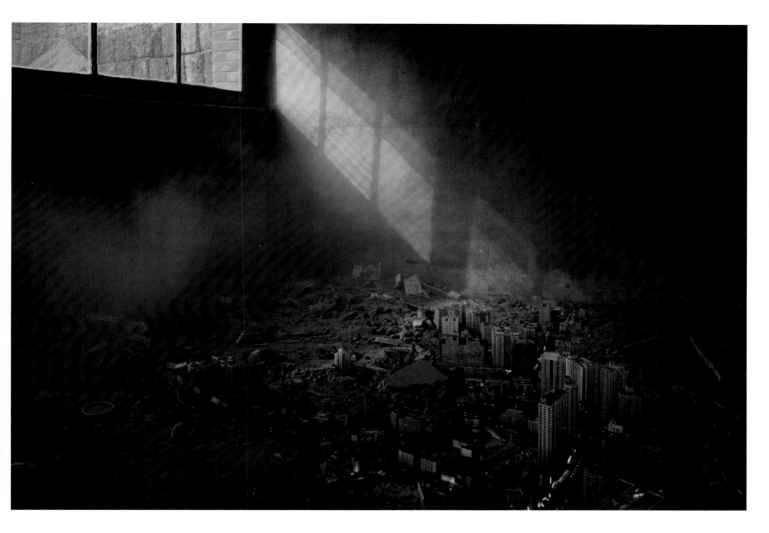

94. Jiang Pengyi, *Unregistered City, No. 1*, 2008

missed in the ruins. The artist calls his cities 'unregistered', and this title is suggestive in several ways. It implies that the cities are not obviously noticeable, hidden in the corners of another reality; it implies that they cannot be recognized as any existing real-life city. It also reminds us of the nature of photography once suggested by Roland Barthes: in comparison with traditional painting, the absence of a 'making' process in photography means that signs and meanings are not linked through 'transformation', but, more effortlessly, through 'registration'.[13] In our post-photographic era, digital tools reopen the space and time for 'making', so that artists can reflect alongside their practice and transform their understandings into visual presentations. Jiang Pengyi is one such artist, working through photographic 'transformation' rather than direct 'registration'. Having now lived in Beijing for many years, perhaps he still doesn't see himself as 'registered' in the city, or perhaps it's the other way round – the city remains 'unregistered' to him as his home.

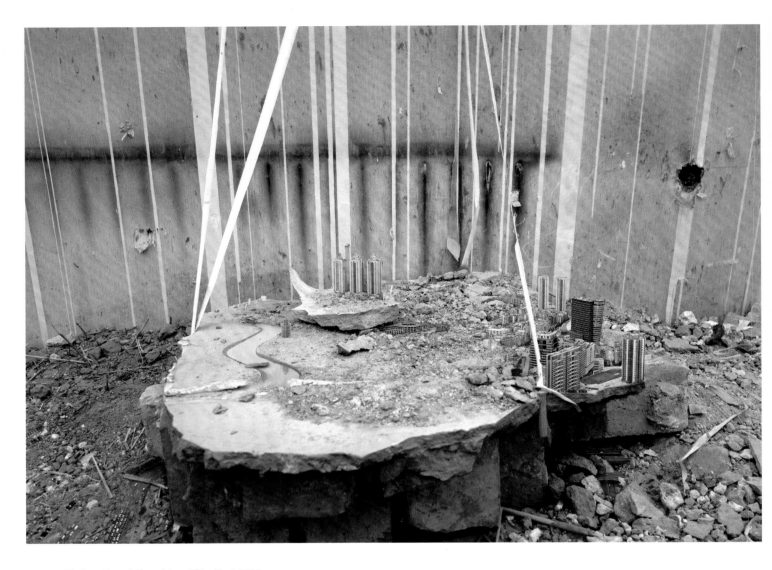

95. Jiang Pengyi, *Unregistered City, No. 4*, 2010

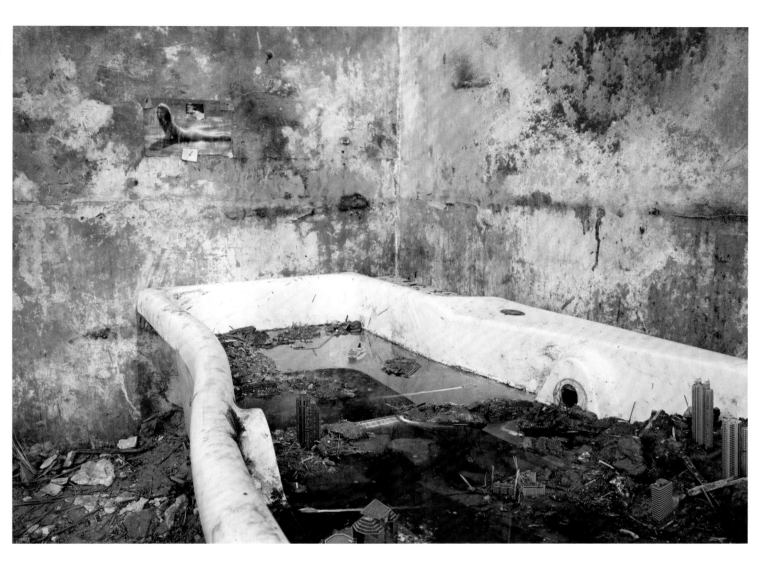

96. Jiang Pengyi, *Unregistered City, No. 7*, 2010

Hu Jieming 'registered' his home to a city incorrectly. In his 2005 project, *Where is My Home*, the Shanghai-based artist and his two assistants spent weeks imposing their hometown on the landform of Guangzhou, which is some 1,000 miles away [97]. In comparison with Shanghai and its Huangpu River, the city of Guangzhou has Pearl River running through the centre, containing Er'sha Island in the middle. Seen from above, the Jiangwan and Haiyin bridges in Guangzhou, for example, have been replaced respectively by Shanghai's Nanpu and Lupu bridges. All the local streets, elevated roads and buildings of Shanghai have, where possible, been transplanted into the topography of Guangzhou, including, identifiably, the Oriental Pearl Tower, Jin Mao Tower and Shanghai Stadium. On a practical level, based on the different widths and directions of highways, and the various shapes and sizes of parks and architectural complexes, it would of course never be possible accurately to relocate one city into another. However, Hu Jieming compared every element of the two cities visually, and calculated how to match them as closely as possible, using any necessary discreet alterations that were supported by the digital technology available at the time. Here, the purpose of the work is not to reflect upon the frustrations and confusions caused by migration, as personally experienced by artists such as Wang Qingsong and Jiang Pengyi. Rather, following the constant urban changes, it creates the ultimate confusion by migrating an entire city, regardless of the inclination of its inhabitants. The development of the work was like undertaking an extremely ambitious puzzle: how to find appropriate pieces of Shanghai and fit them into a satellite image of Guangzhou. In fact, it is more than a puzzle: a new physiognomy has actually been built, a hybrid appearance of two cities. Imagine flying home into this airspace, the city below looking ever so familiar yet ultimately unrecognizable, whether as Guangzhou or Shanghai. It would surely be even more confusing, on landing and getting into the city, to drive along the well-known spiral approach to Nanpu Bridge, and then somehow cross Pearl River instead. As the title of this work indicates, home has become a puzzle. In line with the rapid urban transformation in China today, everything appears to be on the move: home can be anywhere but nowhere.

97. Hu Jieming, *Where is My Home*, 2005

4.
Memories Invented

Reimagining realities lost through environmental transformation

Memories can be attached to a physical space that contains the fluency of things happening in real life, while the space awaits revival through its owners' return. If the space is threatened, it seems convenient to preserve it as a photograph, even if this only offers a flattened and immobilized reality. According to Roland Barthes, 'The photograph does not necessarily say *what is no longer*, but only and for certain *what has been*.' For him, this distinction is decisive, and, 'not only is the photograph never, in essence, a memory … but it actually blocks memory, quickly becomes a counter-memory'.[1] As has clearly been seen in the visual reflections of artists, the appearance of China's cities is ephemeral, changing rapidly from one image to another. The urban landscape, including architectural constructions and environments ranging from traditional to contemporary, Chinese to Western, fake to real, taken in totality presents a hybrid identity. Even home can be alienated. In such a reality, memories are not to be kept, but are essentially to be invented.

The scenes that appear in Hu Jieming's 2008 work, *Son*, were carefully composed with particular criteria in mind. First, according to the artist, it was vital to choose an urban landscape that could represent not only the history and culture of a city, but also its dynamic rhythm, extending down to the next generation. The Bund was one of the few sites in Shanghai that could accommodate the artist's need. Secondly, in order to maximize the vision, a high viewpoint would be required to allow the camera to overlook the city. And thirdly, in terms of the character in the picture, it would have to be someone who had a personal relationship with the artist. Hu Jieming recalls his childhood experiences: 'For some reason, I was obsessed with climbing up to the roofs. It was always a nice moment for me to look aimlessly into the distance from the top of our house.'[2] His memory was retold in the series, in which his own son, as his spiritual extension, literally took up his roof-top position, poised on colonial buildings in an architectural complex [98–100]. With his naked back facing us, and disregarding his precarious position, the young boy must have indulged in his view of the Bund: the beautiful curve of Huangpu River, the busy traffic, the glass curtain walls and construction sites highlighted by variously sized cranes. Above it all is the vulnerable figure of the boy, who seems to be looking for something, or waiting; perhaps for all the noise on both sides of the river to be hushed by a single steam whistle from a ferry coming in at dusk. After some forty years, observed by the two generations who have been living through urban transformation, is this still the same Bund? In fact, the artist was of course positioned behind his son, having a similar view, with his younger version included in the frame. Perhaps they wish they could fly, to have an entire bird's-eye view of the city, or to escape bustling reality into a realm of peaceful memory. But the urban vibrancy carries on as usual, and that longing whistle never sounds.

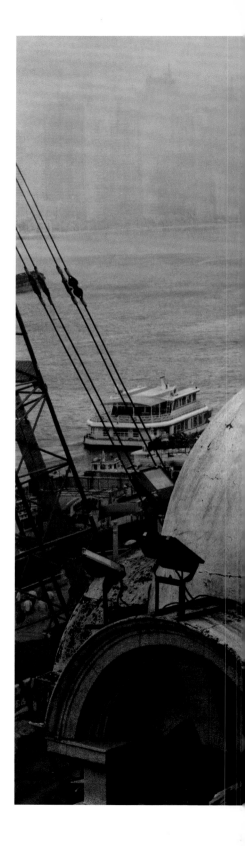

98. Hu Jieming, *Son, No. 2*, 2008

In Shanghai, the old residential areas are quickly disappearing from the cityscape and being replaced with modern high-rises to accommodate the increasing population. What are now missing are the classic 'stone gate' buildings, which a particular neighbourhood – and spiritual legacy of Shanghai – could inhabit and grow in. These densely built terraced houses were normally constructed in a relatively closed area, which fostered an intimate community. They usually had limited interior spaces and yet, between them, their small patios and alley-ways (*nongtang*) became an extended space for social assembly and communication, and were certainly a paradise for children, particularly when a city has few nearby play-areas. Adult men and women could easily chat to each other in their pyjamas outside their houses, and children made their closest friends through games designed specially to suit the structure of the residential complex. These alley-ways formed divisions between individual households and at the same time, they were their joints, with an ambiguous quality between private and public space.

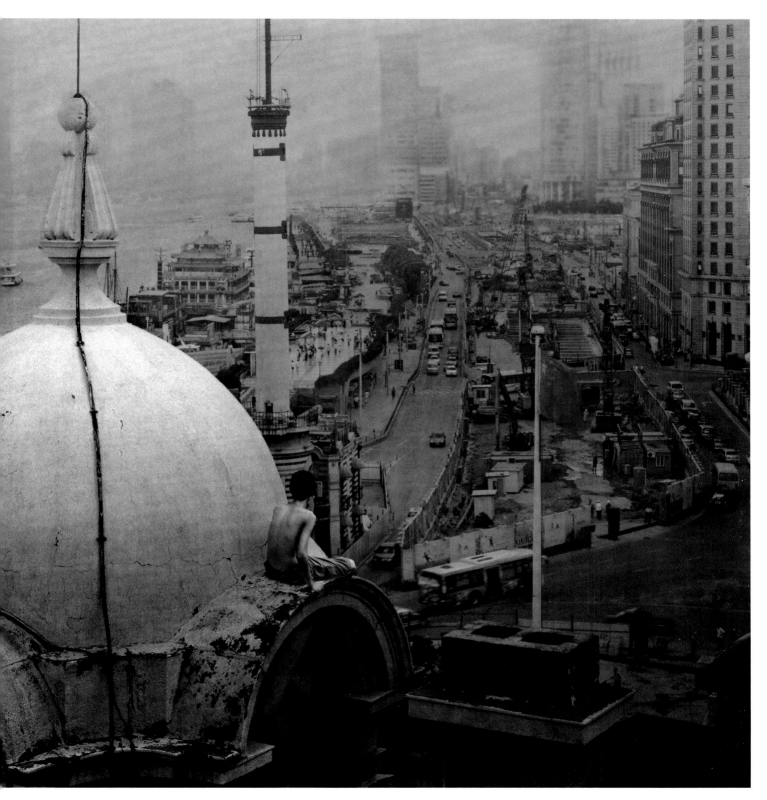

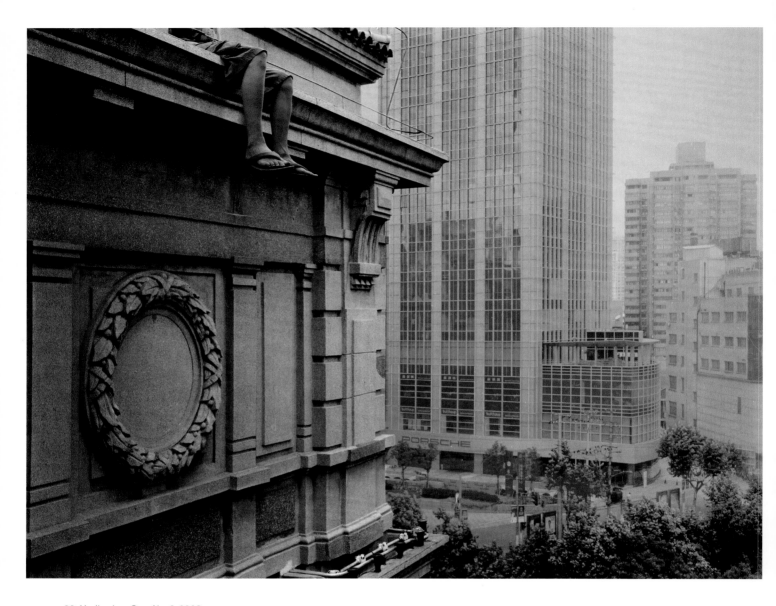

99. Hu Jieming, *Son, No. 3*, 2008

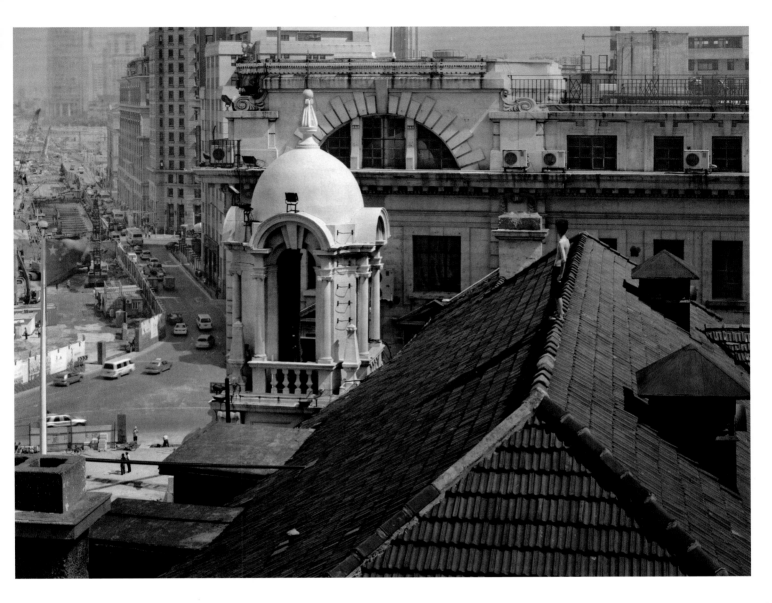

100. Hu Jieming, *Son, No. 1*, 2008

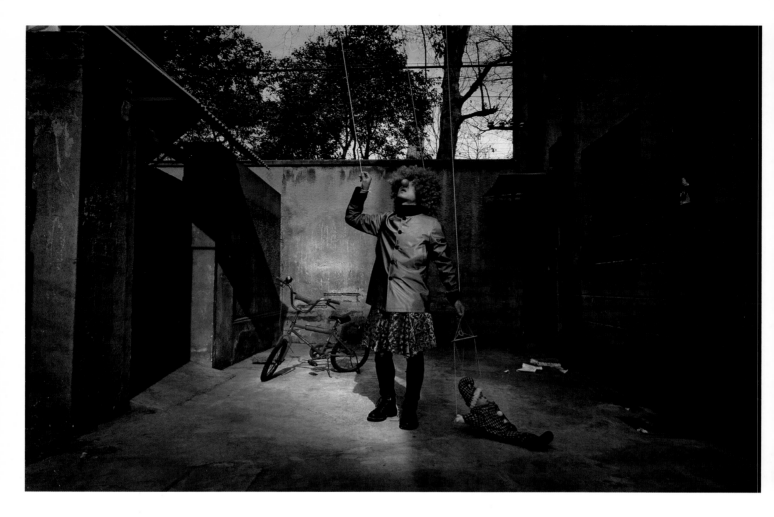

101. Ma Liang, *My Circus, No. 6*, 2004

Ma Liang's work deals with the relationship between the current changing reality and the memory of the past, between existing space and an imaginary world. Old residential areas, just before they were demolished, became final theatres for the artist to stage reinterpretations of his childhood memories. In *My Circus*, he brings his favourite acts back to the alley-ways. In the saturated tonalities of old film, the performers concentrate on showing their specialities, though their audiences are not shown [101, 102]. The *Book of Taboo*, on the other hand, aims to portray daily life itself as a circus and to reiterate a kind of struggle, though possibly a pleasurable one, in rebelling against urban and social confinements. In Ma Liang's daydreams, anyone can be a performer to resist what has been learnt from books of existing knowledge. One individual might dress up as a pilot – in fact, as a bird – to attempt to depart by springing off a seesaw [103]; someone

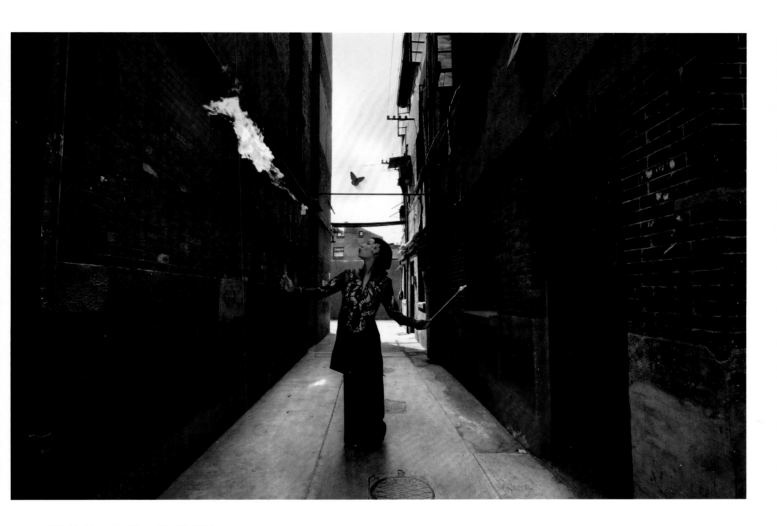

102. Ma Liang, *My Circus, No. 12*, 2004

else might strip naked, possibly in order to reduce his weight down to a minimum so that he can learn to fly from the doves around him [104]. The artist notes: 'I am not interested in observing and catching any moment of actual happenings in secret (like a photojournalist). Those shots of others and of inconsequential events would not be real life to me. Instead, I am always keen to have full control of my subjects, whom I may influence so that they become a particular element of vocabulary or a symbol as part of my stories.'[3] Ma Liang's photographic fictions are therefore not just connected to the artist's camera or to any reliance on forms of digital technology; they are really made through the development of scenographic narratives within or beyond the artist's studio. In his own theatrical spaces, he carefully chooses each character, costume and prop for its individual meaning, and arranges them to play different roles in new contexts.

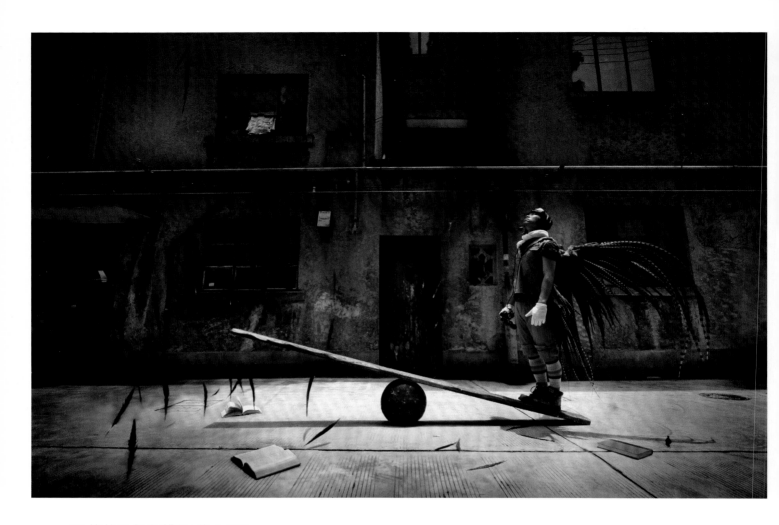

103. Ma Liang, *Book of Taboo, No. 5*, 2006

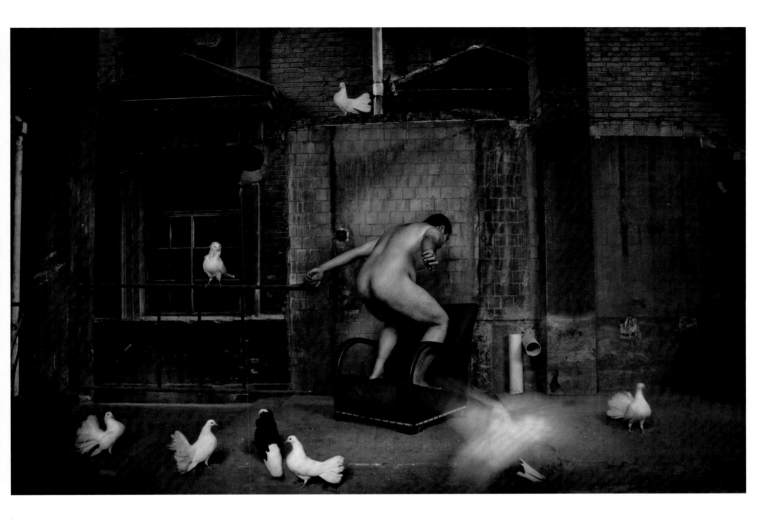

104. Ma Liang, *Book of Taboo, No. 16*, 2006

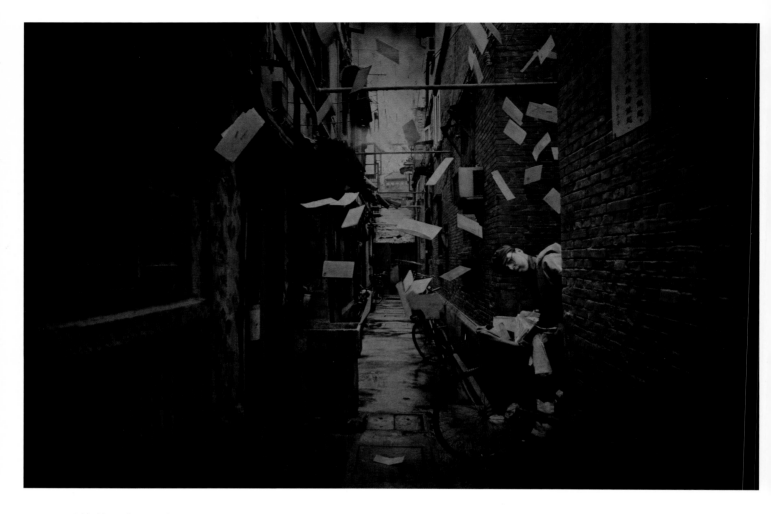

105. Ma Liang, *Postman, No. 4*, 2008

In a work dating to 2008, Ma Liang enlisted the figure of the postman, who would arguably have the best geographic knowledge of a city. Dressed in dark green (a former postal uniform) and covered in a raincoat, this worker would ride his bicycle through the alley-ways of Shanghai, and he knew every inch by heart. But in the artist's dreamlike reinterpretation, the postman travels hopelessly when all the alleys somehow become unrecognizable. A whole day's worth of mail is desperate to fly to its destinations, but the lane and house numbers that the postman remembers seem no longer to be correct [105]. Sometimes the postman despairs and, lifting up his bicycle, attempts to jump from one of the flat roofs into the maze of the city. A suitcase of letters lies yet to be

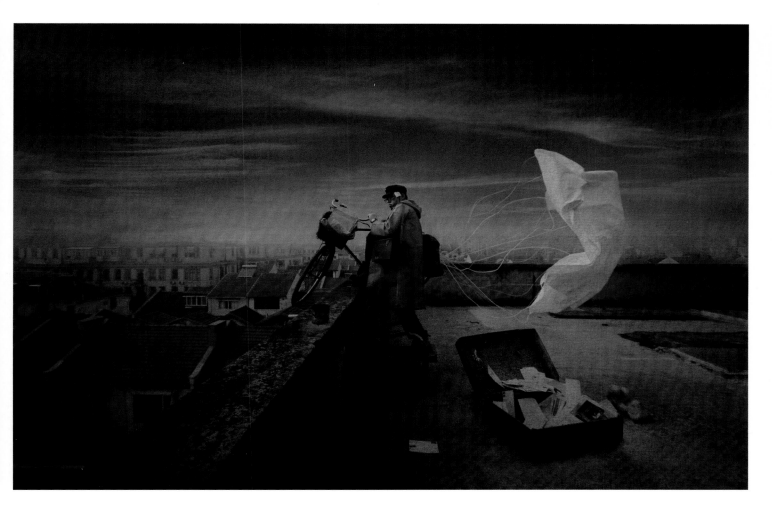

106. Ma Liang, *Postman, No. 1*, 2008

distributed, and the workman's parachute can guarantee neither accurate delivery nor his own safety [106]. Letters are a form of memory, as the art critic Gu Zheng has discussed, and if the letters cannot be sent then this becomes problematic when we try to handle our memories, which have nowhere to go. Ma Liang convinces us that memory needs space to exist, whereas space needs memory to become solid. In his work, the postman is the one who weaves our memories of the city back and forth following district and street names. In his mind, there had been a map of memory, which he relied on to connect people by handing out their greetings. But the fact that he becomes incapable of delivering the post signals a crisis of our memory, and a crisis for the city.[4]

For Chen Man (b. 1980), camera lenses are only instruments for collecting primary visual information, which is then to be reassembled through advanced digital techniques with infinite possibilities. As the artist states, 'I don't see a photographic frame in the conventional terms of composition, light and moment. You could say it sets the stage for the story that I create around the image.'[5] In a series dating to 2009, sometimes the finished image depicts the back of an unidentified (or possibly puzzled) teenager, or, as the title indicates, a (Communist) 'Young Pioneer', looking into the distance, where a hybrid cityscape based on Beijing is formed with varied styles of architecture, ranging from the historical golden roofs of the imperial buildings in the Ming and Qing dynasties, the taller government buildings and residential blocks of the Socialist era, all the way to twenty-first-century skyscrapers, including the cutting-edge CCTV Headquarters [107]. Sometimes a row of these girls stand on top of the newly constructed Three Gorges Dam, as if this has become their 'stage', where they can confidently flick their skirts, as if dancing in the wind [108]. When Chen Man photographs the initial work, her 'stage' is strictly private, with no one in attendance except for the performers and herself as director: the performance at the shooting site is unobserved. For the staging of the work, the artist's audiences wait outside her 'theatre' and are only invited to glimpse periodic views of the show – still images of selected moments. These fragments are then to be connected by the audience themselves to imagine and form a sequence of visual narratives. In Chen Man's work, these narratives seem to be born naturally in an imaginary visual world, rather than captured from reality. Photography is a perfect medium for her to balance the natural and the artificial, the ordinary and ideal, the remembered and actual, with her particular aesthetic approach reflecting afresh upon the desires of an unobtainable past and the most current urban culture.

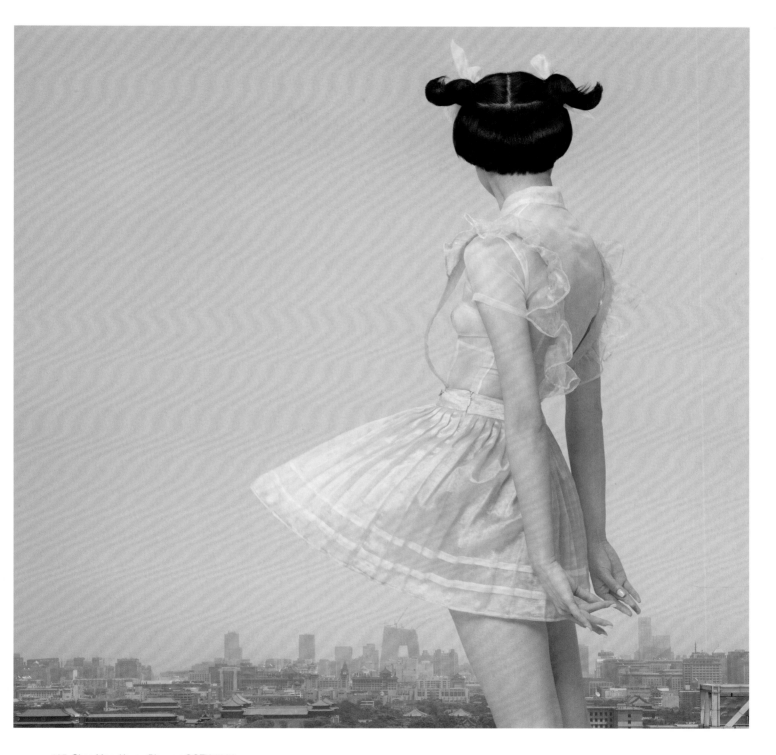

107. Chen Man, *Young Pioneer: CCTV*, 2009

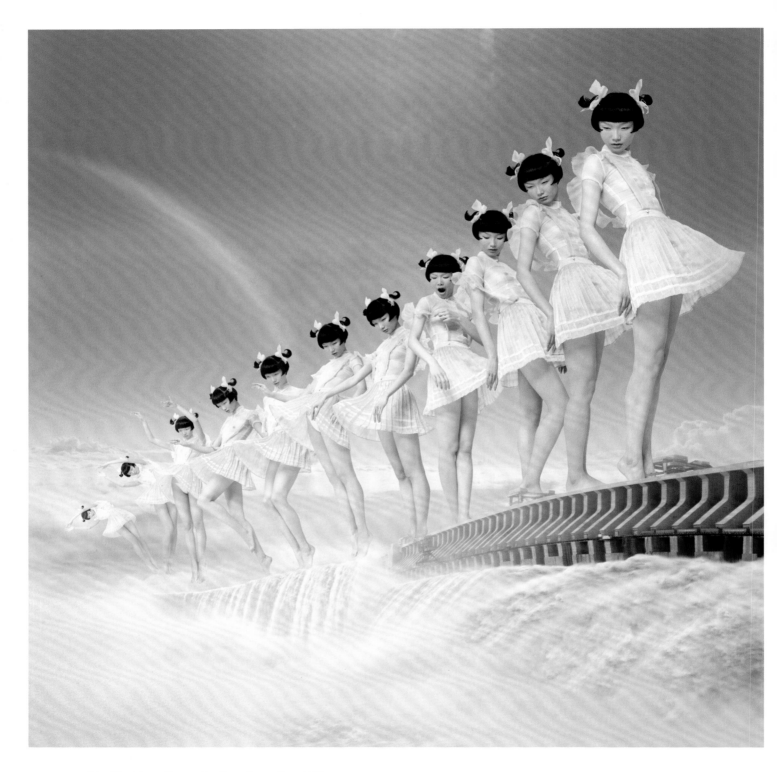

108. Chen Man, *Young Pioneer: The Three Gorges Dam*, 2009

The launch of the Three Gorges Dam project – which disregarded many unsupportive views that were aired during the consultation process – was aimed to create the world's largest hydropower station, and eventually, according to the official report in *China Daily*, to provide 'huge benefits to society and the economy in terms of its functions in flood control, drought prevention, clean energy and navigation'. On 14 December 1994, construction commenced in Sandouping in the city of Yichang, Hubei Province. The dam underwent three further stages of increased water retention, its maximum storage capacity eventually raised to 175 metres (575 ft) above sea level.

In April 1995, well prepared in advance, Zhuang Hui went to the Three Gorges to initiate a long-term art project, *Longitude 109.88° Latitude 31.09°*. This is probably the earliest piece on the dam, its development and aftermath. The artist chose three areas to concentrate on: the initial construction point at Sandouping in Xiling Gorge; a point along the riverbank in Wu Gorge; and Baidi City at the entrance of the Qutang Gorge. Zhuang Hui dug over one hundred holes, each half a metre (1½ ft) deep [109–111]. He photographed these holes, but said little regarding the project – which, at the time, baffled passers-by. Then, in April 2007, after the dam had been completed, the artist hired a cameraman to return to the Three Gorges. Guided by a map, the cameraman was to film the locations where the holes had been left twelve years previously. Just as expected, everything was already gone, and each hole – marking the original banks of the Yangtze River, as well as huge stretches of the natural beauty it had encompassed – had already been swept deep underwater, never to be seen again [112–114]. Art historian Wu Hung has remarked, 'Zhuang Hui does not view these holes as the markers of a performance piece; rather, he envisions them as vestiges of the banks of the Yangtze River itself. Now that there is nothing to see, people will remember those small holes down there somewhere under one hundred metres of water. This photo documentary will become a vestige of a vestige.'[6] In other words, the 'photographic documentation' here serves as the 'original work', presenting a fact that cannot be witnessed firsthand [115].

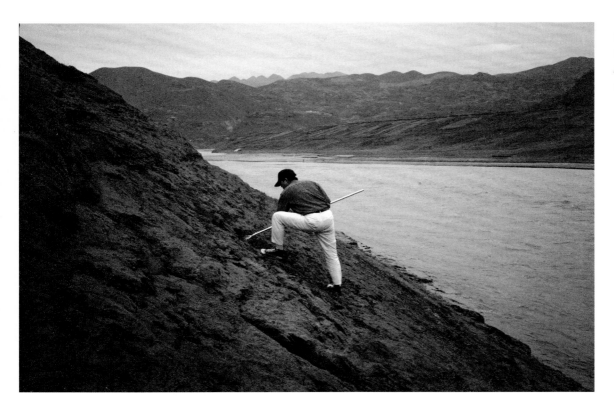

109. Zhuang Hui, *Longitude 109.88° Latitude 31.09°: Digging Holes at Wu Gorge*, 1995

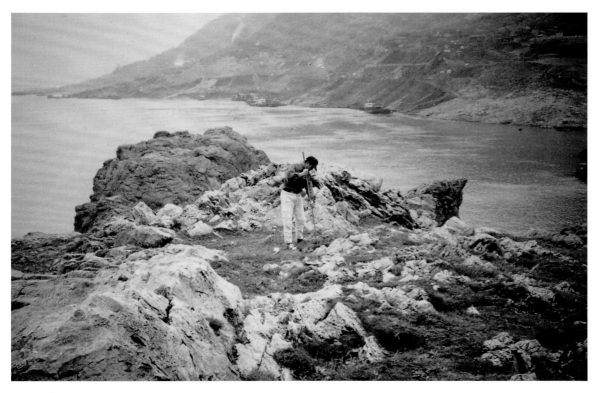

110. Zhuang Hui, *Longitude 109.88° Latitude 31.09°: Digging Holes at Baidi City*, 1995

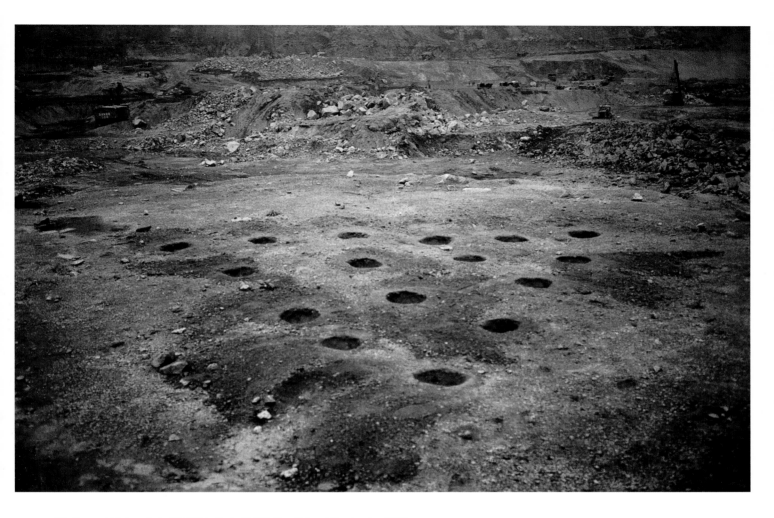

111. Zhuang Hui, *Longitude 109.88° Latitude 31.09°: Dug Holes at Sandouping*, 1995

112. Zhuang Hui, *Longitude 109.88° Latitude 31.09°: Wu Gorge in 2007* (video still), 2008

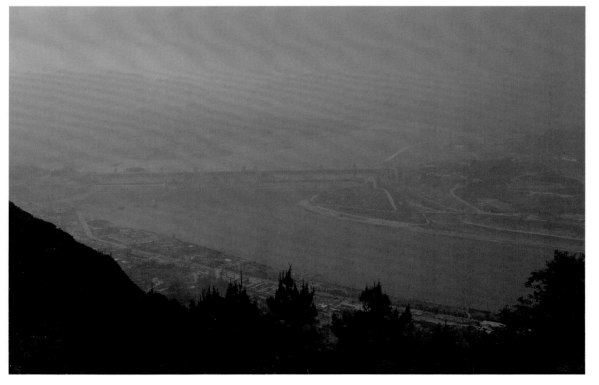

113. Zhuang Hui, *Longitude 109.88° Latitude 31.09°: Three Gorges Dam in 2007* (video still), 2008

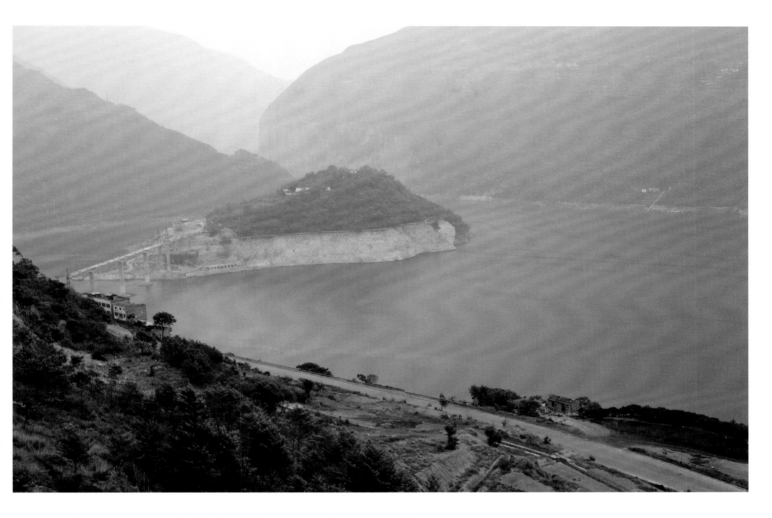

114. Zhuang Hui, *Longitude 109.88° Latitude 31.09°: Baidi City in 2007* (video still), 2008

115. Zhuang Hui, *Longitude 109.88° Latitude 31.09°*, 1995–2008

As the Three Gorges project continued to develop, artists began to engage – from a variety of different perspectives – in the growing critical dialogue surrounding the ecological disruption and human displacement that resulted, but arguably it was Zhuang Hui who was first aware of the dam-building as a significant issue that would affect the lives of millions of Chinese people and their cultural memories. *Longitude 109.88° Latitude 31.09°* was not a 'response' or 'reaction' to the changes brought on by the dam, but rather an 'involvement' embedded within the construction and expected to grow all the way alongside the development. The artist simply announced that some twenty years previously he had dug holes in the ground at various places that had then become invisible, covered by water. His photographs were the only evidence of the artistic intervention. Zhuang Hui did not tell us if he had put anything in the holes … perhaps he planted the seeds of memories.

Information on the impact that the dam, completed in 2009, has had on the local environment still remains unpublished. What we do know is that homes have disappeared, forcing the relocation of tens of thousands of households. The destiny of migration was inescapable, and in 2002 it reached the home county of artist Yang Yi (b. 1971). Kaixian in Sichuan Province – containing an old town with more than 1,800 years of history, home to about 70,000 people – became the last county to be removed to make way for the Three Gorges project. For the artist, it was a nightmare. 'One day, when I woke up on a chilly morning, the images in my dream remained fragmentary but unforgettable. I was walking in my hometown, passing through my old school, the roof terrace of our house, and the alley stairways leading up to the river bank, which was a paradise of my childhood… Everything was so familiar. However, it became terrifying when I suddenly realized that the whole town had been evacuated. I could not find anyone, no family members or friends. Where were all those water bubbles coming from, floating everywhere in the air? I attempted to shout for help, but I was voiceless and struggling even to breathe…'[7] Yang Yi decided to revisit Kaixian in 2007, just before it was submerged. It was only ten minutes in a taxi from the new town to the old, but it was difficult to find a driver to take the job. No one wanted to go there, as at night-time the place appeared ghostly. Almost all the streets and buildings were empty, and there was very little light. The half-ruined structures were dead, like skeletons.

For his *A Sunken Homeland* series, Yang Yi took the last portraits of the old town of Kaixian, including the alley-way between the residential buildings where he lived for many years. All the artist's childhood memories of family, neighbourhood, friends and games were confined to that area. In one image, Yang Yi himself stands with mud from his homeland in his cupped hands [116]. He also invited friends and local children to return to be photographed with their old homes [117, 118]. Astonishingly, during one visit, the group discovered that there were still people living in a half-destroyed dangerous building – possibly as a 'nail household'. Although the inhabitants remained unseen, the smell of their cooking proclaimed heroically that life must carry on.

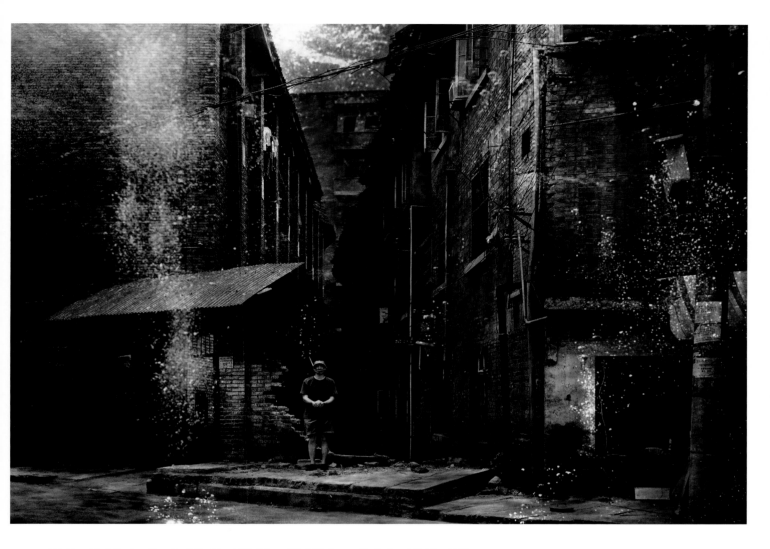

116. Yang Yi, *A Sunken Homeland: Residential Building of Fruit Market on Shuifo Road, Kaixian*, 2007

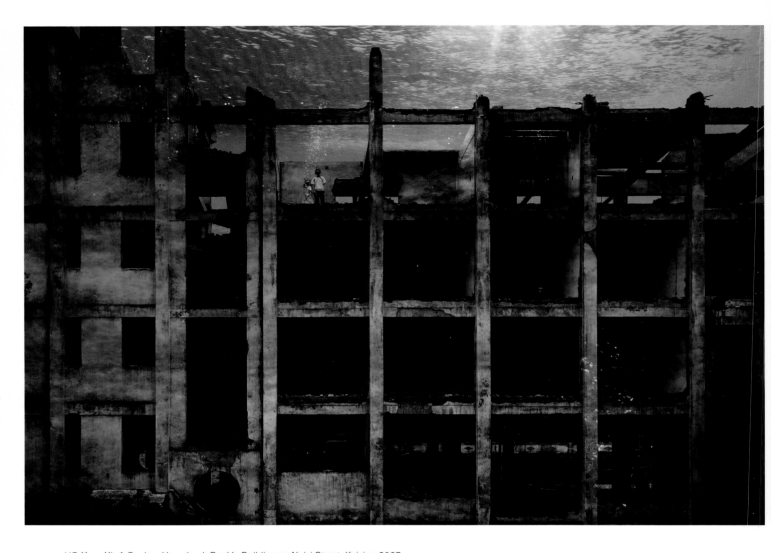

117. Yang Yi, *A Sunken Homeland: Bank's Building on Neixi Street, Kaixian*, 2007

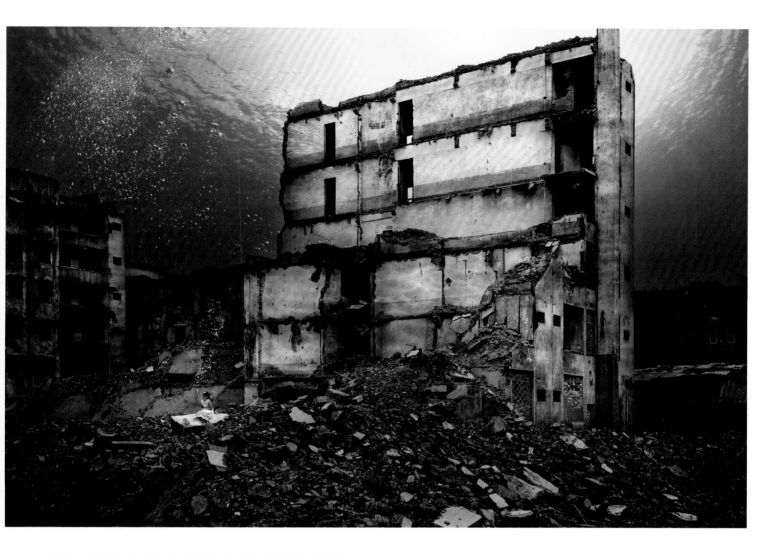

118. Yang Yi, *A Sunken Homeland: Nanjiao Residential Building, Kaixian*, 2007

In Yang Yi's photographic narrative, everyone wears a scuba mask and the entire town is already deep underwater. The mask, on the one hand, assists the homeowners to return, to carry on living in unnatural circumstances; on the other hand, it emphasizes the surrealistic, darkly humorous quality of the work. And yet the memories – without recourse to scuba masks – have sunk, too.

Similarly to Yang Yi, the artist Chen Qiulin (b. 1975) grew up in Wanxian, a small county near the Yangtze River, directly affected by the Three Gorges project when half of the county was flooded and the other half was merged into Chongqing as an urban district of the municipality, called Wanzhou. The artist revisited Wanxian to capture its final appearance before demolition. In her 2007 series, *The Garden*, dozens of peasant workers hold large containers stuffed with gaudy plastic peonies in front of semi-demolished buildings, disappearing alley-ways or else new construction sites for the high-rises being erected to create an urban utopia [119, 120]. In other examples, a group of children dressed in typical late 1970s and early 1980s school uniform, and the artist herself appearing as an angel, are positioned against ruined backdrops showing areas that are undergoing demolition and from which inhabitants are in the process of migration [121–123]. In fact, it can be observed that all the immaculate costumes, including the children's white shirts, navy trousers and red scarves, and the angel's dress with its blue and red stripes, are made from the cheap wrappers used for building materials that can be found everywhere on construction sites in China. The relationship between our memories and the urban changes is reflected through the contrasting juxtaposition of the fragile, vulnerable children and female figure and the decrepit environment behind them. For Chen Qiulin's generation, 'I Love Beijing Tiananmen' was undoubtedly the most popular children's song. In an eponymous work, the angel descends again to bless the group of children who are lined up respectfully in front of Tiananmen Tower, and whose eyes have been heavily rouged, as per the facial make-up used in the Beijing Opera [124]. The background mosaicwork of painted tiles covers the central structure of a primary school as a perfect photographic backdrop, or a nationalistic symbol (see p. 89), for students, staff and visitors. Unfortunately, since this scene was located in the designated reservoir area, the school, the mosaic and all the memories of the Young Pioneer generations must by now be submerged beneath the Yangtze water.

119. Chen Qiulin, *The Garden, No. 5*, 2007

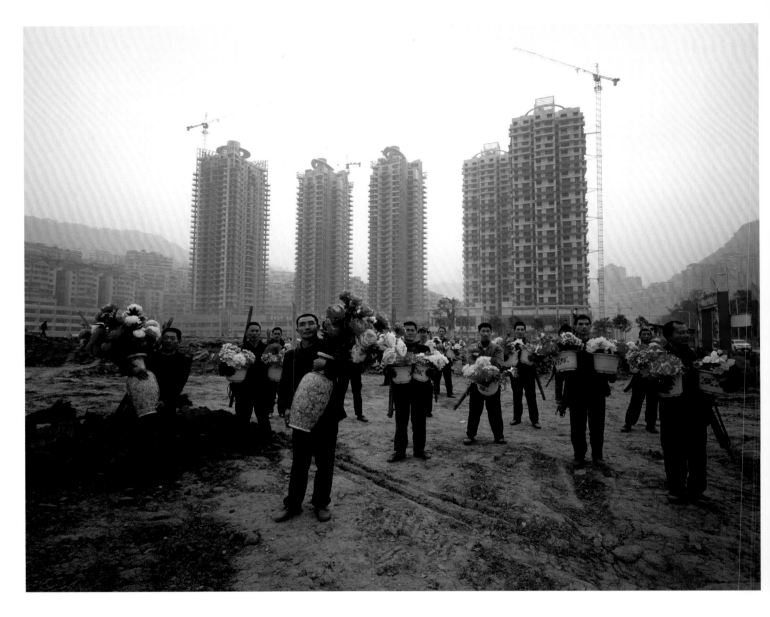

120. Chen Qiulin, *The Garden, No. 4*, 2007

(opposite)

121. Chen Qiulin, *Green Landscape, No. 2*, 2006

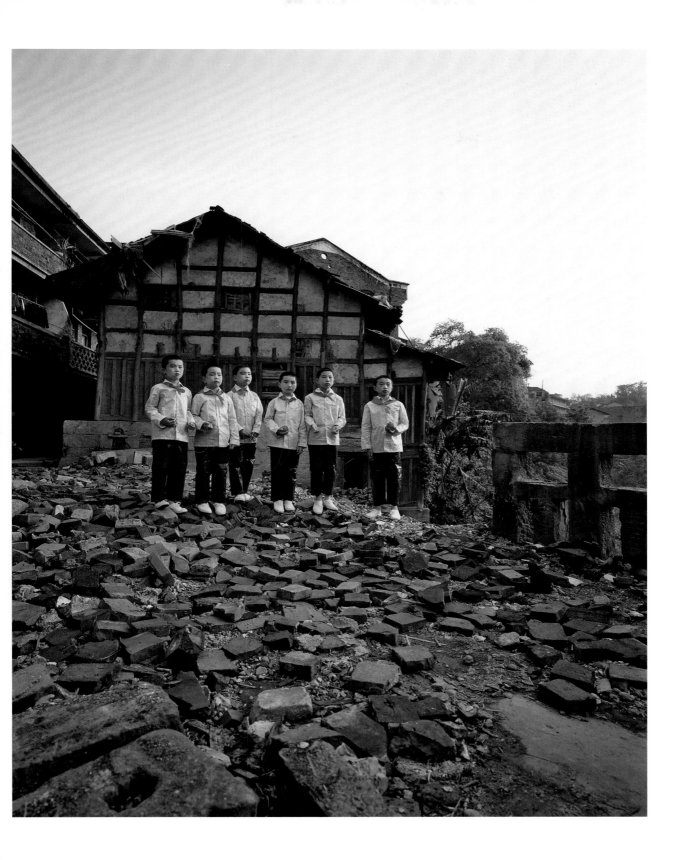

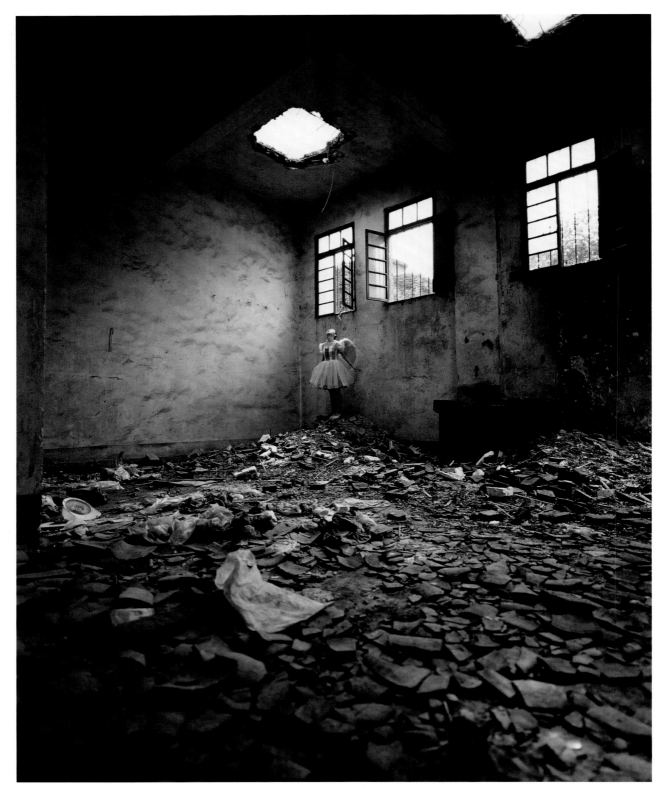

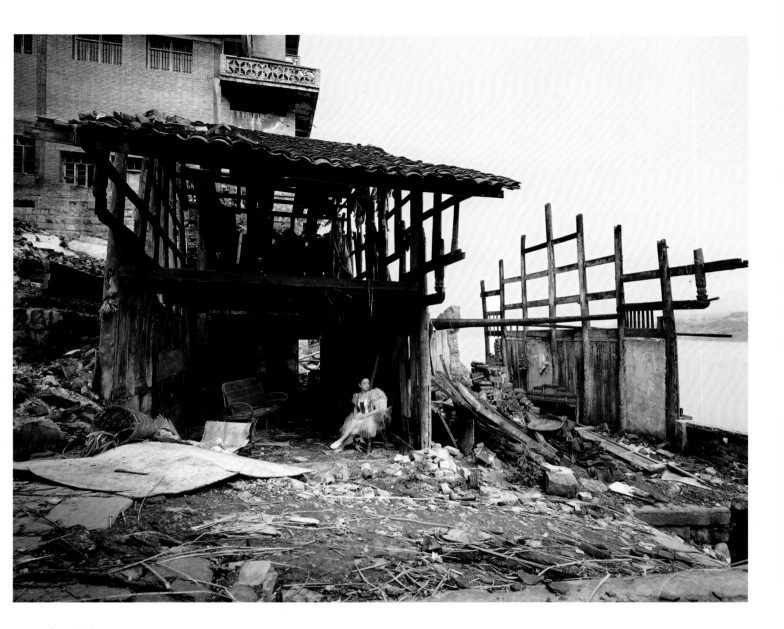

(opposite)

122. Chen Qiulin, *I Am an Angel, No. 3*, 2006

(above)

123. Chen Qiulin, *I Am an Angel, No. 2*, 2006

(overleaf)

124. Chen Qiulin, *I Love Beijing Tiananmen, No. 2*, 2006

Chen Qiulin's key childhood memories pertain to West Hill (*Xishan*) Park, which housed the residence of a Sichuan warlord during the Republic of China, then became the only park in the town. She particularly remembered the Bell Tower and the Garden of Serenity (*Jingyuan*) – to her, the most mysterious places in the park. As she recalls, 'Before the watch had become a common household item in our lives, the Tower told the time for the whole town, with the bell ringing hourly. The rising spiral staircase was closed by a big rusty lock, and I always wondered if there was a Quasimodo hunchback in the tower, believing that in a sense this was the Notre Dame of our town. At the heart of the park, there was the Garden of Serenity decorated with a rockery, pavilions, small bridges over the flowing stream... It was rarely visited. The rooms were empty, and the wooden floor would make a creaking sound when one stepped on it. I did not dare to go there alone, and was scared by its gloomy coldness even on summer days. The adults did not know who had originally lived there, but warned us that a woman's shadow would appear on any photos taken in the place. I therefore never took photos in the Garden, not even one, and the shadow of the mysterious woman kept floating in my imagination and grew up with me.'[8]

By 2012, Wanxian had finally become Wanzhou District or, according to the title of Chen Qiulin's work, 'The Empty City'. In a series of photographs and a seven-screen video work, Chen Qiulin returned not to her hometown, but to the memories of her hometown [125, 126]. She appears dressed in military uniform and wearing a face mask. The uniform belonged to her father and gave her a feeling of love, courage and assurance; the face mask kept her feeling protected, anonymous and safe. Her character holds a bunch of balloons in colourful star shapes, just like the last few matchsticks to be lit by the girl in Hans Christian Andersen's story, to create an illusion of hope once again. As the water rises, the previously fast-flowing Yangtze River appears to have been widened into a huge lake, calmly foregrounding a new cityscape in the distance. Although West Hill Park is still there, the dwarfed Bell Tower – amid the crowded skyscrapers and the bustling environment – has lost its previous dignity, and the Garden of Serenity has disappeared. The legendary woman, even her shadow, would have nowhere to inhabit, apart from the memory of the artist.

125. Chen Qiulin, *The Empty City, No. 1*, 2012

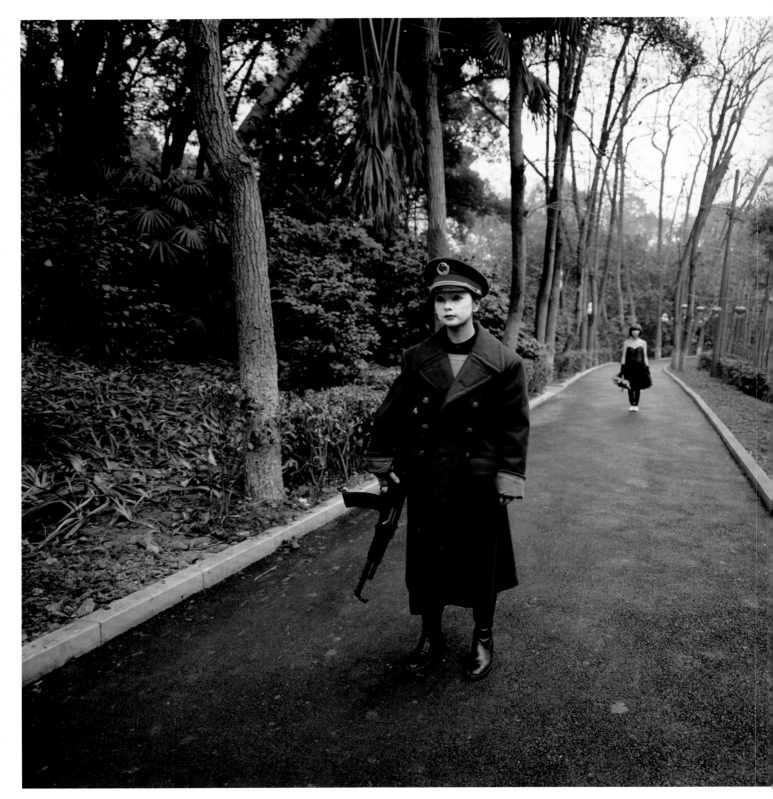

126. Chen Qiulin, *The Empty City, No. 3*, 2012

In 2003, Yang Fudong (b. 1971) produced the first part of his later seminal five-part film, *Seven Intellectuals in a Bamboo Forest* (*Zhulin qixian*), which also includes a series of photographic works [127–131]. The work references the theme of the legendary Seven Sages of third-century China, a group of unruly Neo-Taoist intellectuals who withdrew from their official positions in the Wei and Jin dynasties to play music, compose poems, drink and sing in bamboo groves, and pursue pure conversation and a passion for reckless liberty. Without any clear narrative, each part of the story takes place in a different setting, such as a mountainous area, a rural village, an island or an urban environment, altogether presenting a group of young men and women escaping from reality and, in a different context of existence, re-examining life, desire, sex and death. The work revisits and focuses on the distance between men and women, individuals and society, the past and the present, and reality and an ideal world.

Yang Fudong usually creates his films by carrying out spontaneous shoots with no prepared script. When the work is presented in the form of photographs, one particular fragment of the moving image breaks away from a context that was already less than descriptive and leads the viewer to another still, or another 'there'. According to the artist, the visual quality of black and white imagery offers 'a feeling of separation from reality';[9] indeed, it is a suggestive approach that might lead towards the idea of invented memory.

127. Yang Fudong, *Seven Intellectuals in a Bamboo Forest, Part 2*, 2003

(overleaf)

128. Yang Fudong, *Seven Intellectuals in a Bamboo Forest, Part 1*, 2004

129. Yang Fudong, *Seven Intellectuals in a Bamboo Forest, Part 3*, 2005

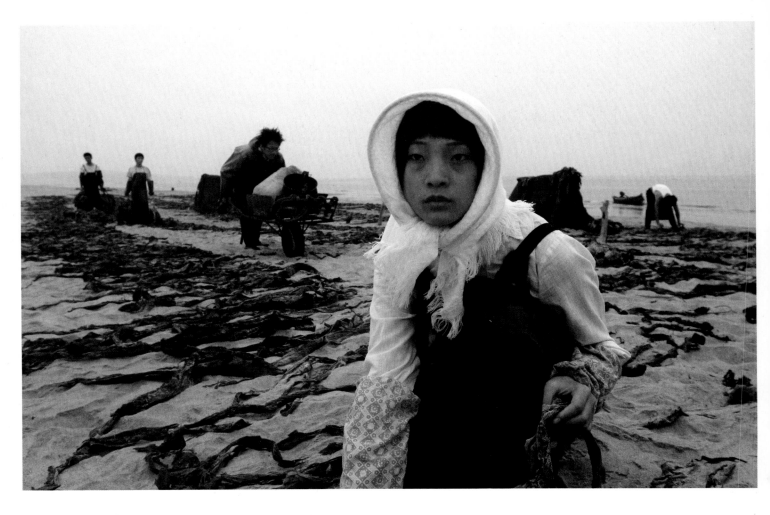

130. Yang Fudong, *Seven Intellectuals in a Bamboo Forest, Part 4*, 2006

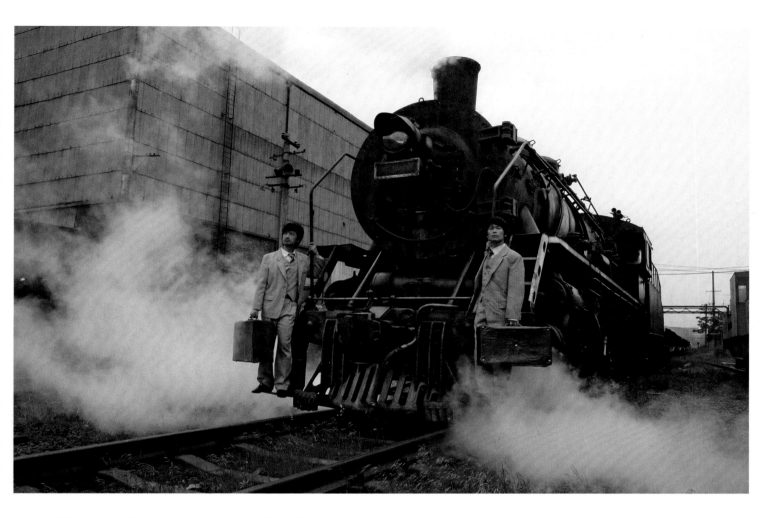

131. Yang Fudong, *Seven Intellectuals in a Bamboo Forest, Part 5*, 2007

Of the city, Yang Fudong has reflected, 'There are some strange places, some strange streets, and at that moment, you are a passer-by.' To him, urban development is designed to provide and encourage an instinctive life that suits our bodily needs. The only way to achieve a spiritual life is to escape from the city, from secularist existence and desires. With all the magic of a visual poem, *Seven Intellectuals* is one of the most serious attempts to picture a utopian destination. The artist continues, 'There's a kind of rumour in cities that produces fantasies, and those rumours create delight. This delight is false, but it influences a lot of people. Saying this brings us to a topic that I have been especially interested in: the capacity of rumours and – here's the main point – delusion. [Photographic] imagery also has this power, like the power of rumours, to delude.'[10] Eventually, such fictions become strangely familiar. Although, with regard to particular social and political references, we can discern neither the timeframe nor the location of Yang Fudong's happenings, it seems that we have somehow already experienced some of these scenarios. Perhaps we have allowed these young people who dwell in a dream-like atmosphere to take us away from reality; or perhaps we are looking at actual situations in their lives, which reminds us to spiritually visit the cultural memories that we already possess and to nurture those that might be shaped in the future.

Photographs – by making visible all the urban transformation in China, which engenders both excitement and anxiety, and results in an ever-changing reality – give people an imaginary ownership of the past and become an alternative place for memory to inhabit. There are several ways of preserving them, including in traditional photo albums or, more practically in the virtual world, with many duplicated copies illuminated by the various screens of our digital devices. As soon as the physical urban environment is reconstructed or disappears, photographic images of the previous appearance become detached from reality as an unreal possession of the recorded, but a real possession of the remembered, the imagined and the invented.

When the medium of photography meets and engages with today's China and the immense upheavals of change, it can be released as a significant creative power. Contemporary photography is not just an independent language for artists to use to reflect visually what has happened in China or, to a certain extent, globally; more importantly, it has become a manifestation of the ephemerality of the world we apparently live in, and it has provided the key to the era beyond our memories.

Afterword

My personal experience happens to have been very useful for observing urban changes in China. I first left my hometown of Shanghai for Britain as a student in the autumn of 1998. Although having lived in England for many years now, I travel back to China regularly – almost every two months in recent years. The image of China keeps evolving and, for the expat, the notion of 'home' begins to shift from the physical to the spiritual. For someone like me, who has very little sense of direction, the changes in China (in Shanghai, in particular) can be felt bodily. My limited geographical knowledge of the city, which I previously learnt through walking and cycling at ground level, has become utterly out of date. Old residential areas have been demolished and replaced by modern office buildings or shopping malls; numerous skyscrapers have risen, as if in competition with each other; little alley-ways have vanished, and new, widened streets have turned into six-and eight-lane highways; at least fourteen metro lines have been built, with multiple connections; and those elevated roads, with apparently no start or finish, have been woven into a new version of urban sky. All these factors have shaped an altogether different city. The house where I was born has disappeared, and my kindergarten and schools have been relocated, rebuilt or renamed. Urban development is not only about construction; it also involves social transformation and – certainly, to me – disorientation, both geographical and cultural. Despite all these years of being away, because of my regular visits back to Shanghai I felt that I never really left home … yet strangely, at the same time, because of the constant changes, I am also convinced that I have never returned.

Notes

Unless otherwise stated, all interviews in this book were conducted by the author. Online interviews were conducted via various means, including emails, Skype and other forms of social media.

Preface

1. Wu Hung, 'Between Past and Future: A Brief History of Contemporary Chinese Photography', in Wu Hung and Christopher Phillips (eds), *Between Past and Future: New Photography and Video from China*. Göttingen: Steidl, 2004, pp. 15–16.

2. Smith, Karen, 'Zero to Infinity: The Nascence of Photography in Contemporary Chinese Art of the 1990s', in Wu Hung (ed.), *Reinterpretation: A Decade of Experimental Chinese Art (1990–2000)*. Guangzhou: Guangdong Museum of Art, 2002, pp. 39–50.

Introduction. 'Urban Appearances'

1. Interview with Xu Nan in China Dialogue (www.chinadialogue.net), 15 October 2013.

2. Qin Shao, *Shanghai Gone: Domicide and Defiance in a Chinese Megacity*. Washington, DC: Rowman & Littlefield, 2013.

3. Hunt, Tristram, *Building Jerusalem: The Rise and Fall of the Victorian City*. London: Weidenfeld & Nicolson, 2004.

4. Li Zhang, *In Search of Paradise: Middle-Class Living in a Chinese Metropolis*. Ithaca, New York: Cornell University Press, 2010.

5. Bosker, Bianca, *Original Copies: Architectural Mimicry in Contemporary China*. Hong Kong University Press, 2013.

6. Katz, Bruce, and Jennifer Bradley, *The Metropolitan Revolution*. Washington, DC: Brookings Institution Press, 2013.

7. Bernath, Doreen (2013), 'China and the Configuration of Reality-Effect'. Unpublished paper.

Chapter 1. Ephemeral Cities

1. MacFarquhar, Roderick and Michael Schoenhals, *Mao's Last Revolution*. London: Belknap Press of Harvard University Press, 2006, p. 118.

2. Johnson, Ian, 'China Plans Vast Urbanization', *New York Times* (International Weekly), 23 June 2013, p. 1.

3. Wu Hung, *Remaking Beijing: Tiananmen Square and the Creation of a Political Space*. London: Reaktion Books, 2005, p. 23.

4. Interview with Shao Yinong, 28 October 2003, Beijing.

5. Wu Hung, *A Story of Ruins: Presence and Absence in Chinese Art and Visual Culture*. London: Reaktion Books, 2012, pp. 216–17.

6. Interview with Shao Yinong, 17 February 2014, online.

7. Interview with Zhang Peili, 13 November 2013, Hangzhou.

8. Chen Shaoxiong, 'Why I Take Street Photos of Guangzhou', 1999, in Ai Weiwei (ed.), *Chinese Artists, Texts and Interviews: Chinese Contemporary Art Awards (CCAA) 1998–2002*. Hong Kong: Timezone 8, 2002, pp. 94–6.

9. Hou Hanru, 'Chen Shaoxiong: From Portable Streets to Private Diplomacy', 2009: www.chenshaoxiong.net.

10. Groys, Boris, 'Art in the Age of Touristic Reproduction', in *Art Power*. Cambridge, MA: MIT Press, 2008, p. 105.

11. Miao Xiaochun, artist statement, 2009.

12. Ibid.

13. Interview with Wang Qingsong conducted by Meg Maggio, 2009, published in *Art Asia Pacific*, Issue 68, May–June 2010.

Chapter 2. The Otherness of the Real

1 Interview with Shi Jian, 13 January 2010, online.

2. Sontag, Susan, *On Photography*. London: Penguin Books, 1979, p. 9.

3. Mitchell, William, *The Reconfigured Eye: Visual Truth in the Post-Photographic Era*. Cambridge, MA: MIT Press, 1992, p. 225.

4. Interview with Miao Xiaochun, 22 March 2006, Beijing.

5. Jansen, Gergor, 'Post-History's Beijing Just So', in Uta Grosenick and Alexander Ochs (eds), *Miao Xiaochun: 2009–1999*. Cologne: Dumont, 2010, p. 127.

6. Mu Chen, letter to the author, 2 January 2014.

7. Wang Chuan, artist statement, 2009.

8. Wang Qingsong, artist statement, 2004.

9. Interview with Jiang Zhi, 26 October 2007, online.

10. *World's Largest Miniature Scenic Spot: Splendid China Catalogue*, ed. Tse Kin Sui and Wong Wing (Shenzhen: Shenzhen World Miniature Co., 1989, p. 6), quoted by Nick Stanley in 'The Public Representation of Ethnic Minorities in China in the Past and Present', presented at the Third Annual Conference of the Centre for Chinese Visual Arts: *Public Space, Art and the Collective Memory*, 9–10 November 2009, Birmingham Institute of Art and Design.

11. Stanley, Nick, ibid.

12. Interview with Yang Zhenzhong, conducted by Lu Leiping in 2003, Shanghai.

Chapter 3. An Alienated Home

1. The 'one hundred chai' correspond to the traditional decorative image of 'one hundred shou' (*baishou tu*) for festive occasions, in which the character *shou* (longevity) is created in one hundred calligraphic variants.

2. Interview with Wang Jinsong, 25 March 2006, Beijing.

3. Rong Rong and Inri, artist statement, 2013.

4. Zhang Dali, artist statement, 2003.

5. Wu Hung, *A Story of Ruins*, op. cit., pp. 229–30.

6. Interview with Yao Lu, 23 December 2009, online.

7. Groll, Elias, 'The East is Rising', 13 August 2012: foreignpolicy.com/articles/2012/08/13/the_east_is_rising.

8. Interview with Xiang Liqing, 28 February 2005, Shanghai.

9. Ma Liang, artist statement, 2011.

10. Florence, Éric, 'Debates and Classification Struggles Regarding the Representation of Migrants Workers' [sic], *China Perspectives* [online], 65, May–June 2006: chinaperspectives.revues.org/629.

11. Wang Qingsong, artist statement, 2005.

12. Jiang Pengyi, letter to the author, 9 December 2013.

13. Barthes, Roland, *The Responsibility of Forms: Critical Essays on Music, Art, and Representation*. Oxford: Basil Blackwell, 1986, pp. 32–33.

Chapter 4. Memories Invented

1. Barthes, Roland, *Camera Lucida: Reflections on Photography*. London: Vintage Books, 1993, pp. 85 and 91.

2. Hu Jieming, artist statement, published in *Hu Jieming*. Shanghai: Shanghart Gallery, 2010, p. 190.

3. Ma Liang, artist statement, 2008.

4. Gu Zheng, *Contemporary Chinese Photography*. Beijing: China Youth Press International, 2011, p. 114.

5. Interview with Chen Man, conducted by Karen Smith, March 2009, published in *Chen Man: Works 2003–2010*. Hong Kong: 3030 Press, 2010, p. 28.

6. Wu Hung, *Re-Imagining the Real: Photography Show of Gao Lei, Shi Guorui, Yang Fudong and Zhuang Hui*. Hong Kong: Timezone 8, 2010, p. 5. Quoted by Jiang Jiehong in text written for the Fourth Guangzhou Triennial catalogue.

7. Interview with Yang Yi, 24 October 2007, online.

8. Chen Qiulin, artist statement, 2011.

9. Zhang Yaxuan, 'Interview: the Power Behind', in *Yang Fudong: Seven Intellectuals in a Bamboo Forest*. Stockholm: Jarla Partilager, 2008, p. 179.

10. Ibid, pp. 175–76.

Credits

p. 7 Photos – Library of Birmingham; pp. 16, 45, 90 and 91 courtesy Zhang Peili, Boers-Li Gallery; pp. 32, 33 and 107 courtesy Rong Rong, Three Shadows +3 Gallery; pp. 93, 94, 95, 134–35, 138–39, 140 and 141 courtesy Hu Jieming, Shanghart Gallery; p. 101 courtesy Yang Zhenzhong, Shanghart Gallery; pp. 118, 119 and 120–21 courtesy Yao Lu, 798 Photo Gallery; pp. 124–25 courtesy Luo Yongjin, Ofoto Gallery; pp. 149 and 150 courtesy Chen Man, LA Louver; pp. 159, 160 and 161 courtesy Yang Yi, Galerie Paris-Beijing; pp. 163, 164, 165, 166, 167, 168–69, 170–71 and 172–73 courtesy Chen Qiulin, Thousand Plateaus; pp. 175, 176–77, 178–79, 180 and 181 courtesy Yang Fudong, Shanghart Gallery. All other images courtesy of the artists.

Jiang Jiehong wishes to thank all the artists who have inspired and supported this book.

Index